IMAGES
of America

VINTON COUNTY

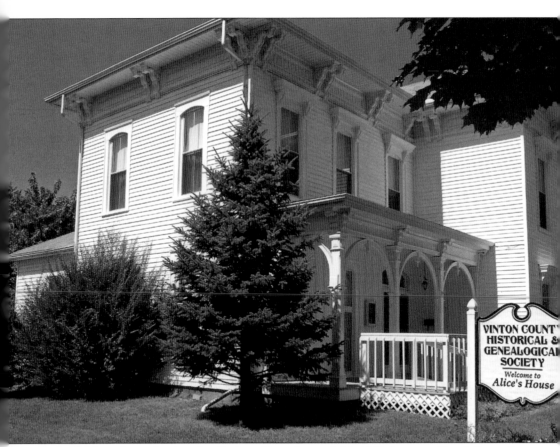

In 2000, resident schoolteacher Barbara Litter donated this 1860s home on South Sugar Street in McArthur to the Vinton County Historical and Genealogical Society. In her family since 1939, the building was named Alice's House in commemoration of Litter's grandmother. Operated by dedicated volunteers, the society preserves antiques and memorabilia, a library and photograph collection, and family and community histories and conducts genealogical research. (Vinton County Historical and Genealogical Society.)

ON THE COVER: A sawmill operation in the 1920s illustrates the once-common use of teams of oxen in logging. Although slower than horses, oxen were more sure-footed on hilly terrain. Most oxen used in such tasks were males at least four years of age. The animal has been described this way: "An ox is a mature bovine with an education." Note the split-rail fence in the background. (Vinton County Historical and Genealogical Society.)

IMAGES
of America

VINTON COUNTY

Deanna L. Tribe with the
Vinton County Historical and Genealogical Society

ARCADIA
PUBLISHING

Published by Arcadia Publishing
Charleston, South Carolina

Printed in the United States of America

Library of Congress Control Number: 2014951298

For all general information, please contact Arcadia Publishing:
Telephone 843-853-2070
Fax 843-853-0044
E-mail sales@arcadiapublishing.com
For customer service and orders:
Toll-Free 1-888-313-2665

Visit us on the Internet at www.arcadiapublishing.com

*This work is dedicated to everyone with Vinton County roots,
wherever they may be, and who treasure it as home.*

CONTENTS

ACKNOWLEDGMENTS

Thanks to the many people who have made this pictorial history of Vinton County possible. They have spent time going through their scrapbooks and memories, searching for photographs and information that help tell the story of our county. This is a representative, not a comprehensive, history, partly determined by the parameters of the Images of America series, but mostly by the photographs available in quality suitable for reproducing. I am sure that there are many more photographs that could have, or should have, been included, but I was not aware of them. Perhaps this book will stimulate interest in searching through family albums, identifying pictures, storing them, and sharing them for others and future generations to enjoy and to become connected to their own people and place.

This book would not have been possible without the Vinton County Historical and Genealogical Society, which made its collection of photographs and reference materials available with the assistance of the helpful volunteers at its location at Alice's House in McArthur. Henceforth, photographs from its collection will be identified as VCHGS. In addition, images were provided by the following, listed alphabetically: Rose Ann Bobo, John Cline, Joe Coleman, *Courier* files, Alberta DePue via daughter Shirley Graham, Clara Jane Dodrill, Mary Downard, Gearing family, Glandon family, Frank Griffy, Nyla Holdren, Bruce Knox, Connie Largent, McArthur Christian Church, Linda McKibben, Lawrence McWhorter, Moonville Rail-Trail Association, Orphan's Friend Masonic Lodge, Jordan Pickens, Paula Pickens, Vicky Schlosser, Joyce Sheline, Rita Teeters, Jean Ward, Steve Warthman, Vinton County Extension Office, Vinton County National Bank, Betty Lou Wells, Constance White, and Gayle Young. If I missed someone, it was unintentional.

And, finally, thanks to Ivan Tribe, my husband, a retired history professor, for making this effort as historically accurate as possible. He provided photographs, conducted research, and helped write captions and chapter introductions, which taken together present a basic history of the county. Jake Bapst's technical support and advice were much needed and appreciated. And, Katie, thanks for keeping me company during the many hours spent at the computer working on this book!

INTRODUCTION

When Ohio became a state in 1803, settlement had hardly begun in what later became Vinton County. Originating with an act of the Ohio Legislature on March 23, 1850, Vinton County was named for Whig congressman Samuel Vinton of Gallipolis. The new county's territory was carved out of portions of neighboring counties and had a population of 9,338. The area included some favorable farmland, but timber and mineral reserves were even then deemed to be economic attractions. The county, comprising 414 square miles and in 2013, has 13,276 residents.

Established in 1815 as McArthurstown, McArthur was designated the county seat when Vinton was formed, taking its name from Duncan McArthur, a general in the War of 1812. In 1850, McArthur had a population of 424. It was noted for high-quality buhrstones, important in early settlement. The original courthouse was built in 1856, and the current courthouse was dedicated in 1939. McArthur's estimated population in 2013 was 1,691 village residents. A yearlong celebration for its 200th birthday will take place in 2015.

Much of the dense hardwood forest was cut for settlement for use in iron furnaces and for lumber. Today, about 82 percent of the county is covered by forest. The county has been known for its production of quality hardwood lumber, and forestry continues to impact the economy. Timber businesses range from logging and small sawmill operations to larger mills and dry kilns. Recent data indicates the direct impact of the county's forest industries at $32.8 million and the number of those employed in some aspect of the forest industry at 200.

Minerals also brought people to early Vinton County. Iron ore constituted the principal economic industry, with six charcoal iron furnaces constructed in the 1850s. Each furnace employed several dozen woodcutters, miners, and laborers during the periods of time they were "in blast." These furnaces were the scenes of thriving little communities. The furnaces were named Eagle, Hamden, Zaleski, Hope, Richland, and Vinton; the latter three were the most significant. Vinton Furnace attempted converting to coke toward the end, but without success because local coal did not "coke" well.

The Marietta & Cincinnati Railroad crossed the county in 1856, leading directly to the founding of the town of Zaleski, named for an affluent Polish count who was then exiled in Paris. Railroad car shops, along with some smaller developments in coal and iron, resulted in Zaleski's becoming the largest town in Vinton County by the mid-1870s. The town declined after the shops burned down and were rebuilt in Chillicothe. The county's population peaked at 17,000 in 1880. Many of the people who originally came to work in the Zaleski railroad shops were emigrants from Ireland and Germany who brought their Catholic religious heritage with them. Other little towns from those days eventually disappeared, leaving only their colorful names to remind folks of their former existence: Elko, Hawks, and Moonville. The latter's tunnel attracts visitors, no doubt for its romantic name, ghost legend, and developing rail trail.

A second rail line, extending from Logan to Gallipolis, crossed Vinton County in 1880, entering McArthur and intersecting at Dundas with the earlier route (by then known as the Baltimore & Ohio). Although designed largely to transport iron ore from locations such as Creola and Oreton to the coal-fueled furnaces in the Hocking Valley, the Hocking Valley Railway further opened the county to northern Ohio.

Bricks were another important industry in the early 20th century. Brick plants flourished for a time at Puritan, near Hamden. Ruins of the kilns and stacks can barely be seen today. The McArthur Brick Plant, established in 1905, closed in 1961. Local structures and those in distant locations were built using these bricks.

Coal was another significant mineral in the history of Vinton County, and it was the major one until recent years. While the area has many older abandoned mines, there were newer ones, too, including underground mines as well as surface operations. While strip-mining for coal created environmental problems in the past, more recently lands have been reclaimed and again made productive.

Agriculture has been important throughout the county's history. Early farms made families nearly self-sufficient. Vinton County farming today, a $5.2 million business, primarily consists of small-farm operations by farmers who also hold other jobs. Because of the hilly land, farms tend to be relatively small and produce a variety of products, including feeder calves, forages, and crops. Land in the western part of the county, the Salt Creek Valley, is farmed on a larger scale. Some of the oldest communities in Vinton County, such as Wilkesville, served as supply centers for area farmers. Like farmers in all places, they constructed various types of barns and other structures that farmers adapted to their needs. Some of these structures can now be appreciated for their artwork, such as the 27 quilt barns.

Not everyone who originally settled in Vinton County remained; some moved farther west, establishing communities and leaving the graves of their ancestors behind. Genealogical information can be gathered from the tombstones, which stand as memorials to departed loved ones. Many churches dot the Vinton County countryside, some of which are no longer in use; others have become nondenominational and serve to forge community identity.

Educational facilities have progressed, from one-room schools in the 19th century, to the larger consolidated schools of the early 20th century such as the old Swan Central School, to the modern schools of today. The five school districts (Allensville, Hamden, McArthur, Wilton, and Zaleski) were consolidated in 1966 into a single Vinton County Local School District. New buildings and more consolidation has occurred since 2000 with the high school and middle school campus at the western edge of McArthur, Central Elementary in McArthur, South Elementary north of Hamden, and West Elementary at Allensville.

McArthur, Hamden, Wilkesville, and Zaleski are all incorporated villages, while Allensville, Dundas, and New Plymouth are the main unincorporated communities. Signs of community development include McArthur's Wyman Park, Herbert Wescoat Memorial Library, Vinton County Historical and Genealogical Society, expanded fire department building, three apartment complexes, Subway and McDonald's, and Dollar General and Family Dollar stores. Unfortunately, McArthur's (and the county's) only supermarket closed in 2013. Economic enterprises associated with coal, gas, timber, farming, education, government, retail sales, sawmill and timber businesses, and Austin Power Company's Red Diamond Plant provide employment. Many residents, however, drive to other counties for work.

Examples of public services and modern buildings include the following: the Vinton County Community Building; Vinton County Health Department; Emergency Medical Services; Hopewell Medical Center; Maple Hills Nursing and Rehabilitation Center; Vinton County Airport; new fire department buildings in Harrison Township, Wilkesville, and soon near Allensville; rural water in many parts of the county; and recent sewer systems in Hamden and Zaleski. The Vinton County Commissioners, the Vinton County Chamber of Commerce, and the Vinton County Convention and Visitors Bureau promote the county for economic, community, and tourism development.

Rugged scenery, beautiful lakes, streams and creeks, trees, hills, covered bridges, wildlife, and community festivals and celebrations have played important roles in attracting tourists and visitors to Vinton County as well as contributing to a quality of life and sense of community for residents.

One

McArthur,

Elk Township, and

Vinton County

Prior to Vinton County's formation in 1850, the largest settlement concentration in what became the new unit was in the westernmost extension of Athens County. As the anonymous author of *History of Hocking Valley* wrote in 1883, "The early settlement of Vinton County . . . centered . . . around McArthur and Elk Township." The Athens County Commissioners created Elk Township on March 7, 1811. It included adjacent territory to the east, north, and south.

By most accounts, the first settler was Levi Kelsey in 1802. In 1806, a Mr. Musselman discovered buhrstones, which were used in grinding grain. Within a few years, others settled, quarrying the stones that they traded for necessities. James Bothwell and his wife, Charlotte, came to Elk in 1814. She left a memoir, recalling that there were about 50 area households.

Later, five men formed a company, purchased 160 acres, and on November 25, 1815, laid out a townsite they named McArthurstown, after Duncan McArthur, a general in the War of 1812. Within a year, six or seven houses went up, and in 1816 Joel Sage opened a tavern at the corner of Main and Market Streets. McArthurstown became a post office in 1826.

By 1850, McArthurstown contained 424 residents, and the township's population was 1,645. Incorporated in 1851 as McArthur, it became the county seat. The village began to mature as a community. Methodists organized in 1814 and built a brick structure in 1843. Citizens started a school in 1820. Presbyterians had an edifice in 1851. Delta Masonic Lodge was chartered in 1851. Judges presided in churches until completion of the courthouse in 1856.

McArthur's population reached 900 by 1880 and 1,107 in 1910. Churches and lodges increased in number, thriving in the coming years. In 1882, Elk Township's one-room schools totaled nine, serving the township's 254 pupils. McArthur had an additional 361 students. The Vinton County National Bank served the county, beginning in 1867. McArthur had become a developed community in a century. These photographs with brief descriptions mainly trace the 20th century.

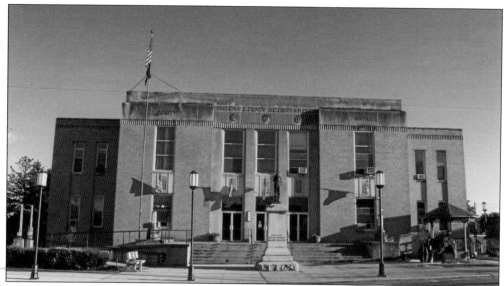

Vinton County's second courthouse structure, built on the same site as the original one, was dedicated on November 29, 1939, by Ohio Supreme Court chief justice Weygandt. The cost was $136,363, with the county providing $75,000 and the remainder coming from a Public Works Administration grant. Several improvements, including an elevator, have been added to this public building, which is still in use. (VCHGS.)

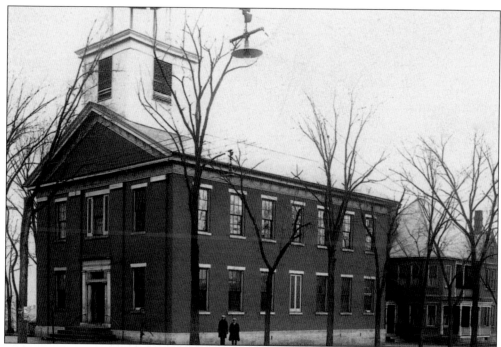

The original Vinton County Courthouse in McArthur, built at a cost of $4,000, served as the seat of county government from its completion in 1856 until it was replaced in 1939 with a new structure built as a New Deal project. The building to the right formerly housed the jail; it now serves as the sheriff department's office. (VCHGS.)

The Vinton County War Memorial honors Union army veterans. The memorial was originally located in the street, but highway modernization and the construction of a new courthouse in 1939 led to its being moved, first to the paved street-level area in front of the new structure. It was then placed atop the soldier's memorial in front of the courthouse, where it now stands 20 feet tall. (Author's collection.)

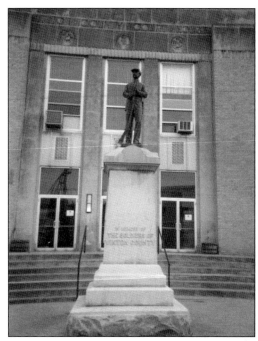

Clara Jane Dodrill submitted the winning design for the Vinton County flag in the contest held by Vinton County 4-H Junior Leaders and the bicentennial committee. The Vinton County Commissioners passed a resolution on November 17, 1975, declaring Dodrill's design the county's official flag. The Vinton County Historical Society provided the first prize, a painting of the county's covered bridges by Larry Murdoch. (Courtesy of Clara Jane Dodrill.)

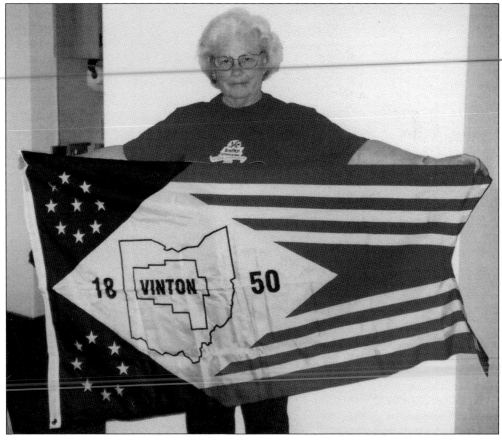

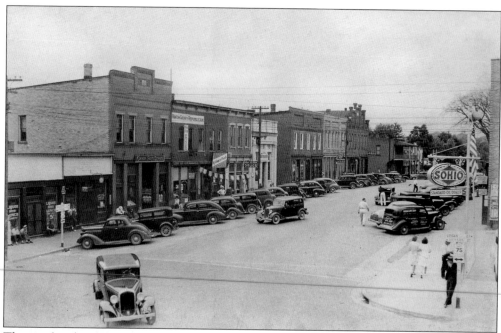

The south side of West Main Street is seen here sometime in the late 1930s or early 1940s. Note the Sohio sign (right) and the angled parking, then common on both Main and Market Streets. The photograph was probably taken from the roof or an upstairs window of the Hotel McArthur. (VCHGS.)

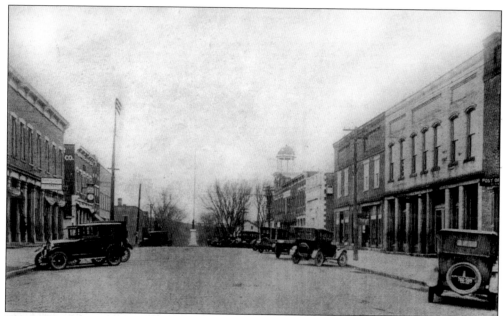

This 1930s photograph of downtown McArthur looks down Main Street from the west, about where the village hall currently is located in a building on the right. Note the cupola on the original courthouse (right of center). The Civil War soldier statue stands in the middle of the street. (Courtesy of John Cline.)

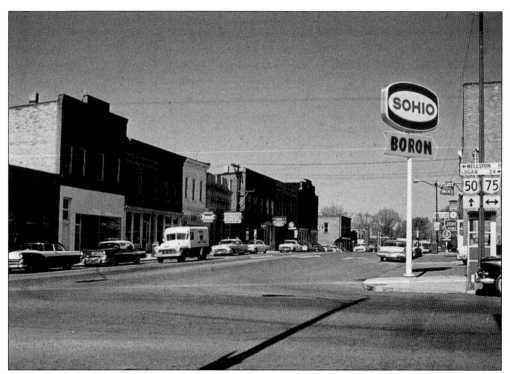

Prior to 1962, State Route 93, which runs north and south through McArthur, was State Route 75. The Ohio Highway Department changed the number to 93 to avoid confusion with Interstate 75, which runs from Toledo to Cincinnati. This scene from the early 1960s looks west on Main Street from the northeast corner of Main and Market Streets. (Courtesy of Jordan Pickens and the Moonville Rail-Trail Association.)

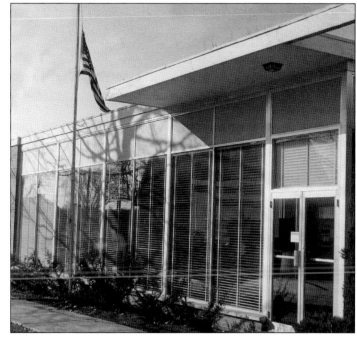

McArthurstown became a post office on April 4, 1826, and its name was changed to McArthur on April 2, 1851. Postmasters were federal political appointees in those days, and the locations changed often. The current post office site on South Market Street dates from 1960, shortly before former state representative Theodore R. Boring became postmaster. (VCHGS.)

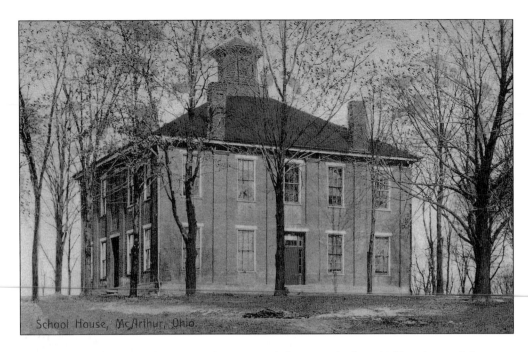

School House, McArthur, Ohio.

The two-story brick school in McArthur pictured above was built in 1860 and served the town until 1915. By 1877, the school had graduated its first high school class from a three-year program. This 66-foot-by-62-foot building was replaced in 1915 with the structure shown below. It served as the McArthur High School until 1966, when consolidation resulted in it serving as the Vinton County High School. A new high school building was erected in 2000. The 1915 building currently houses the University of Rio Grande's McArthur Center and the Vinton County Local Schools administrative offices. Activities and events still take place in the gymnasium and on the football field. (Above, VCHGS; below, courtesy of Clara Jane Dodrill.)

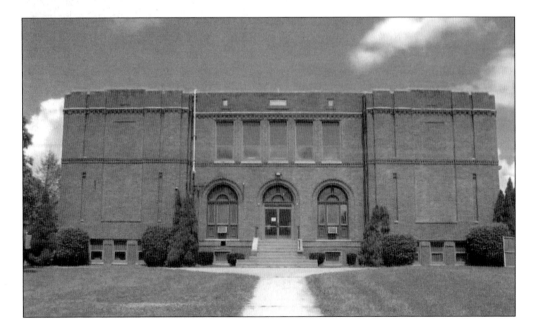

For several decades, the Vinton Theater, located in McArthur's Memorial Building, provided Vinton Countians with motion-picture entertainment and occasional live productions. In later years, the theater auditorium was divided, allowing two films to be shown simultaneously. This winter scene is from the early 1940s. (VCHGS.)

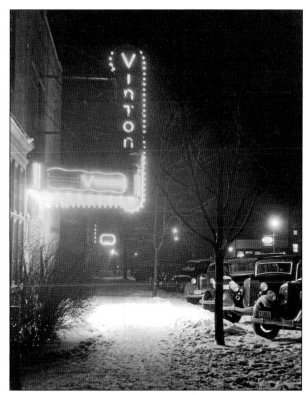

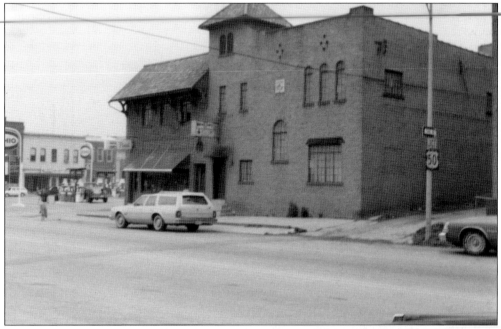

Delta Lodge No. 207, Free and Accepted Masons, has been a McArthur institution since 1851, meeting in various locations. For more than 50 years, its lodge hall has been at 107 North Market Street. In 1925, Delta Lodge had 125 members. Membership peaked at 288 in 2010. (Author's collection.)

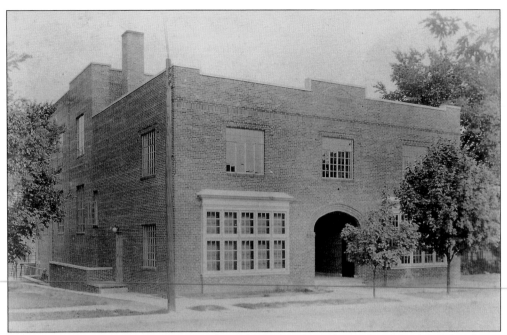

Dedicated on July 4, 1934, the Memorial Building (above) was located on North Market Street in McArthur. It stood until about 2007, when the building, beyond repair and renovation, was demolished by the new owner, the Herbert Wescoat Memorial Library. The McArthur Civic Club (below) and the American Legion owned the lot. Through a variety of creative fundraisers, the organizations generated funding to help construct the large, two-story brick building. The auditorium had a stage and seated 500 persons. Over the years, a variety of agencies and organizations occupied space in the Memorial Building. In the 1930s, it housed McArthur's first public library. The Vinton County Board of Elections was among the last occupants. (Both, VCHGS.)

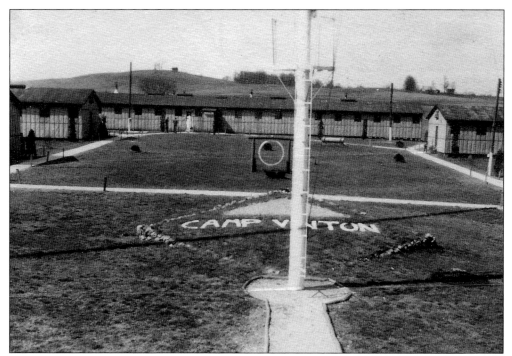

Camp McArthur was on the "old fairgrounds" in McArthur. The Civilian Conservation Corps (CCC) provided temporary employment for thousands of young men across the country in the New Deal era. Many CCC projects involved reforestation; much of the softwood forests in Vinton County were planted by CCC workers. The Soil Conservation Service operated Camp Vinton for work on private farms. (VCHGS.)

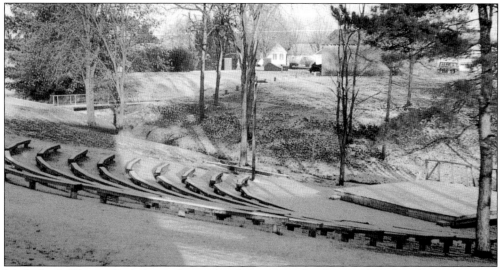

McArthur's Wyman Park, located near the elementary school, sees a lot of use by youth sports teams, family gatherings, children enjoying the playground equipment, and folks playing tennis. Established in the early 1970s, the park's impetus came from a $10,000 gift from Harry B. Wyman, who was born and reared in the McArthur area. The amphitheater seating seen here has since been removed. (Author's collection.)

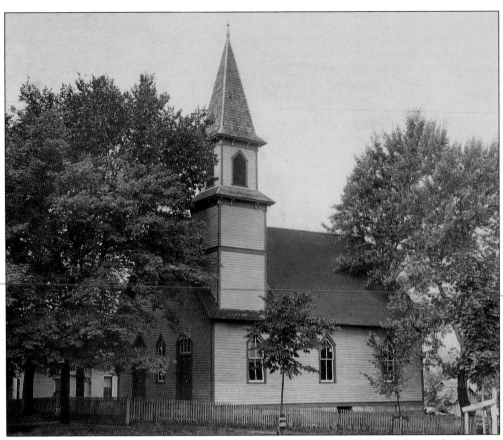

Seen above in an early photograph, the Presbyterian Church at West High and Boundary Streets in McArthur still holds services today. It is part of an ecumenical ministry that also includes Wilkesville Presbyterian Church and Trinity Episcopal Church. The congregation was formed in 1838, and the building was constructed in 1851. Entry is through twin double doors, and the current furnishings date from the 1950s. The sanctuary's focal point is a white oak cross, handcrafted by Elder Harold Felton. There are no altars in Presbyterian churches, so this church has a table set out from the wall in the front of the sanctuary. Below, the congregation gathers for a photograph in 1962. (Above, VCHGS; below, courtesy of Vicky Warthman Schlosser.)

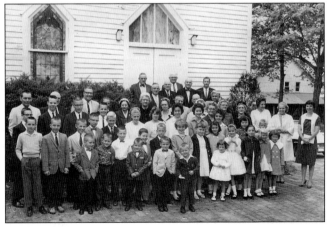

Trinity Episcopal Church, a beautiful example of Late Gothic Revival architecture, is listed in the National Register of Historic Places. Built in 1882, Trinity Episcopal Church, located at West High and North Sugar Streets in McArthur, still holds services on the third and fourth Sundays of every month. It is often open for self-guided tours during special events in McArthur. (VCHGS.)

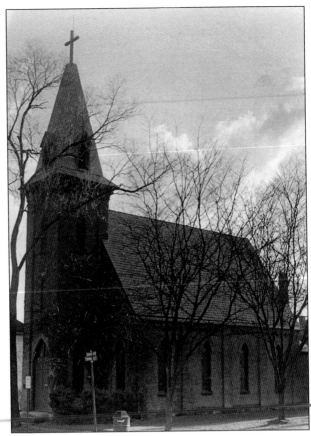

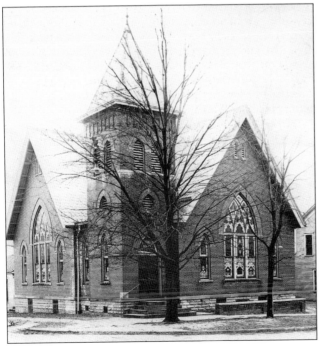

Dedication services for this McArthur Methodist Episcopal Church (the town's oldest congregation) occurred on May 8, 1904. The church had been erected the previous year. This attractive building replaced earlier Methodist churches in McArthur. Located on South Market Street, the church has had its original slate roof replaced and an addition built, resulting in an improved facility for the active congregation. (VCHGS.)

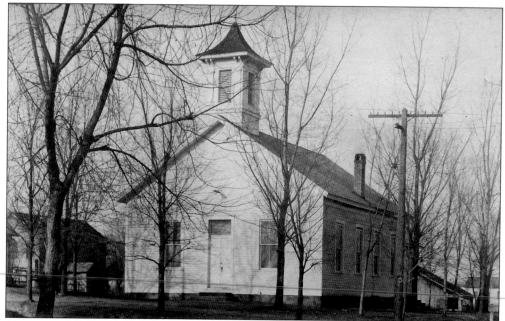

The McArthur Christian Church was built in 1861–1862 on East High Street. Schism occurred over such issues as instrumental music in the services and the use of either a common or individual communion cup. The congregation survived, and membership grew to about 120 by 1919. This brought about changes in the church's appearance, especially the outside structure around 1921, as seen in this early photograph. (Courtesy of the McArthur Christian Church.)

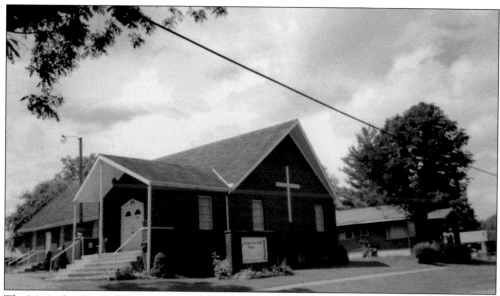

The McArthur Freewill Baptist Church, located on West Main Street, has been in existence since the mid-1960s. The congregation met in the basement for five or six years until the main church structure was completed about 1972. Founding member Jerry Griffith Sr. pastored the church for 25 years. He was followed by others in the Griffith family. (Author's collection.)

The Calvary Assembly of God Church was organized in 1982 by Rev. Carl Radcliff, who remains the pastor. The congregation met in various locations until it built a church on State Route 93 North. The building was subsequently sold to another church. The current structure (pictured) is located on US Route 50, west of McArthur, across from the Vinton County High School. (Author's collection.)

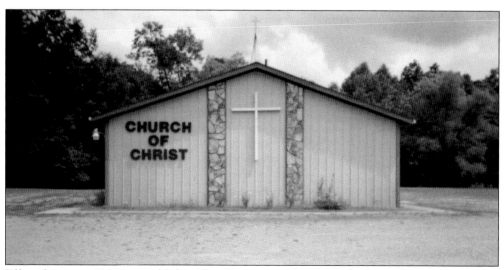

Efforts began in 1986 to establish a New Testament Church in the McArthur area. The first services were held in January 1988 in the Vinton County Community Building. Meanwhile, in 1987, three lots at 440 Engle Drive were purchased, and construction began on a steel building in April 1988. Dedication was held on November 6, 1988. Pictured is the church, which also has a fellowship hall. (Author's collection.)

The Grace Baptist Church filled a need for a Southern Baptist congregation in Vinton County. The first service was held in November 1959. A large home was purchased in 1971 for services and became the permanent location on East High Street in McArthur. The present structure dates from June 1984. It was built in six days by Carpenters for Christ; an educational addition went up in 1995. (Author's collection.)

Following a successful tent revival in July 1935 organized by Rev. Riffle of Hamden and Reverend Shaffer, there were enough people to establish the McArthur Nazarene Church. Services were held in a private residence for three years. In June 1939, the doors opened on the current church, located on North Market Street. It has undergone several changes and additions over the years and continues with an active congregation. (Author's collection.)

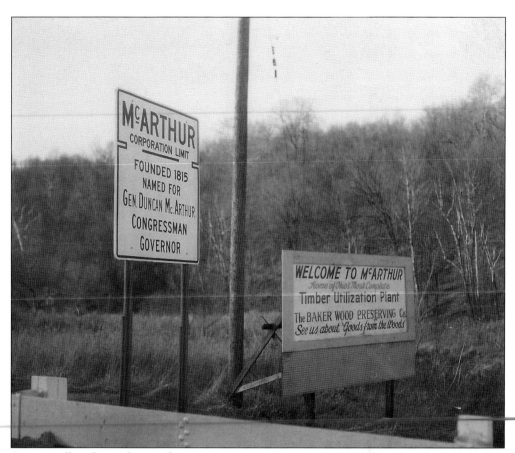

Signs at village limits frequently give an idea of a community's history and values. The above photograph indicates that McArthur was established in 1815 and that it was named for a significant political figure in Ohio's history. The welcome sign located an important McArthur lumber business in the 1950s, the Baker Wood Preserving Company, which had the promotional slogan, "see us about goods from the woods." The sign shown at right (no longer standing) invited visitors to enjoy the friendly people and beautiful scenery offered by McArthur. (Above, VCHGS; at right, author's collection.)

McArthur attorney Otto E. Vollenweider was a longtime Republican leader. In 1955, at 89 years of age, he was the oldest living attorney in Ohio. He also had been elected county prosecutor and state senator. Vollenweider, a faithful member of McArthur Christian Church, is pictured here in June 1950 at a church function, flanked by Jody Morrison and Ralph Bratton. (Courtesy of the Alberta DePue collection.)

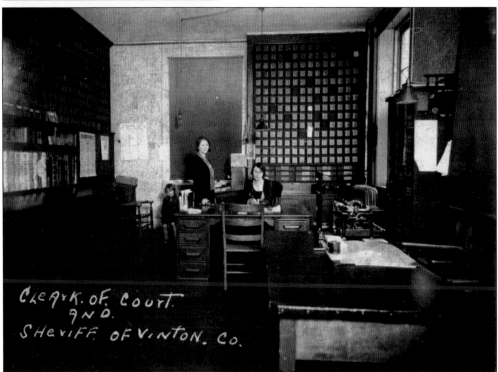

CLERK. OF. COURT.
AND.
SHERIFF. OF VINTON. CO.

Maude Collins (1893–1972) is justly honored for being Ohio's first female sheriff. In 1925, she filled out her murdered husband's unexpired term and was elected in 1926 to her own full term. She later held the elected office of clerk of courts. Collins (standing) is pictured here with her daughter Margie and an unknown employee (seated) in the clerk's office in the old courthouse. Collins eventually held a state job in Columbus. (VCHGS.)

This 1948 photograph of Bethel's Sohio Station, a longtime fixture at the corner of Main and Market Streets in McArthur, shows gas pumps parallel to Market rather than Main, as they were in more recent times. In later years, Charles Peters and Sons held forth at this locale. Since 2013, it has been Bud's One Stop, a convenience store selling Valero gasoline. (Courtesy of Jean and Clarence Ward.)

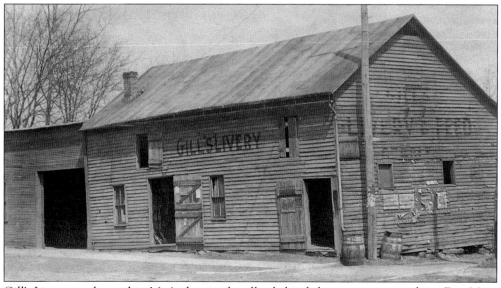

Gill's Livery was located in McArthur in the alley behind the current car wash on East Main Street. This was the beginning of the Gill family's involvement with transportation businesses. In the 1940s, the Gills had a vehicle dealership on South Market Street near the post office. Later, Gill's Chevrolet was located on East Main Street. The site is now the home of AHOY Transportation. (VCHGS.)

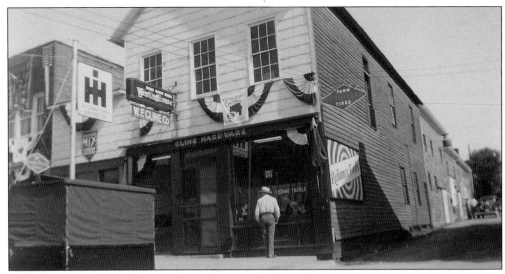

Cline Hardware on Main Street, pictured at the time of the 1950 centennial, has been a business of long standing. It was originally operated by Wallace F. Cline (1904–1985), then for many years by his younger brother Sheldon "Tate" Cline (1913–1993). Known as Standard Hardware and Supply Company, the business remains in the Cline family, with Tate's son Andy in charge. (Courtesy of Clara Jane Dodrill.)

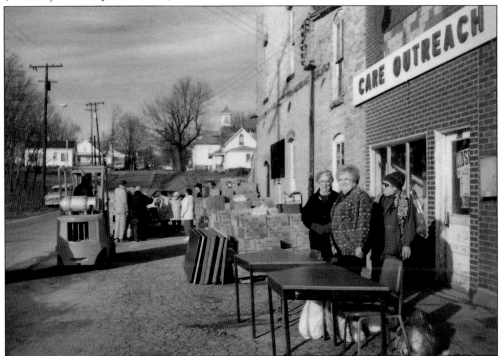

CARE Outreach, a volunteer ministerial effort serving those needing assistance with food, clothing, and housewares, is located on East High Street. It occupies the three-story structure that formerly housed McArthur Supply, a business operated by Frank Crow from 1975 until it closed in December 1990. The building-supply business was started at the end of World War II by Evan Dixon, Jack Kwatkowsky, and Joe Salts. (VCHGS.)

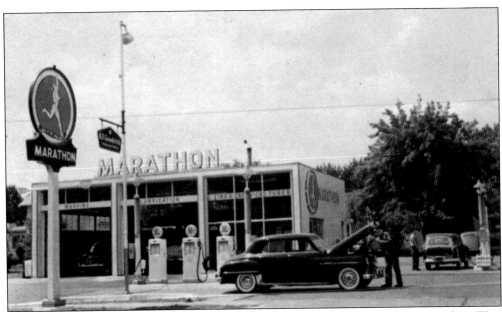

Burson's Marathon Station, seen here in a mid-1960s company postcard, was located on West Main Street in McArthur. Unlike today's convenience stores selling gas, or self-pump gas stations, Burson's and others of the time serviced and repaired vehicles. This service station went through several different owners before closing. McClures Restaurant, a regional chain from Meigs County, now occupies the site. (VCHGS.)

John Crow's Firestone business on West Main Street in McArthur is pictured here in 1950. Elected mayor at 23, Crow later served as Vinton County treasurer (1958–1965), during which time he owned the Firestone store and the Marathon station. Crow was the last surviving charter member of McArthur's Fraternal Order of Eagles No. 2279. He died at the age of 100 in 2013. (Courtesy of Clara Jane Dodrill.)

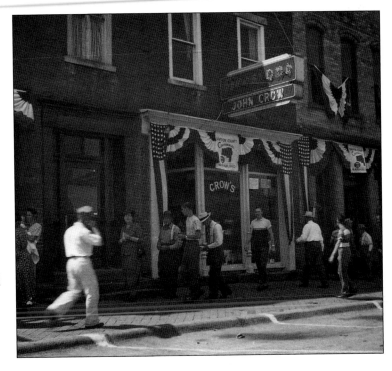

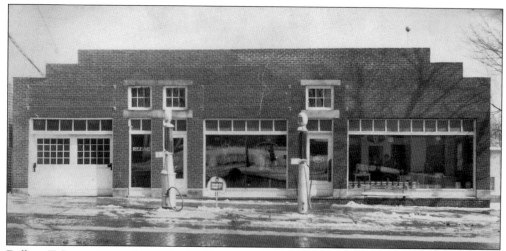

Delbert T. Reese operated a car dealership and gas station on South Market Street in McArthur. The fuel was distributed through gravity gas pumps, which were more common at the time. Reese served for many years as admissions director for Rio Grande College in Gallia County and was active with the Republican Party. (VCHGS.)

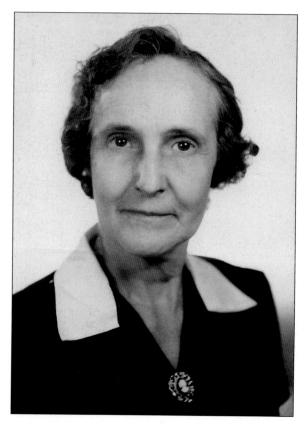

Ethel Cox's Economy Store in McArthur is remembered by local folks who patronized the interesting array of merchandise as children. Shopping the glass penny-candy jars was a delight. Some bought a bottle of Evening in Paris perfume at her store, which she operated for 50 years. Cox had been active in the community until she died in 1968 at age 76. (Courtesy of Rose Ann Jarvis Bobo.)

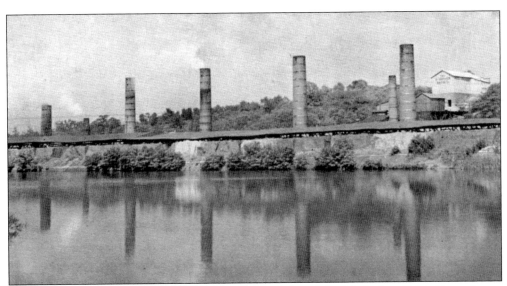

The kiln stacks by the railroad and pond are symbolic of the McArthur Brick Plant. It was established about 1905 and ceased operation early in 1961. It was locally owned and managed, with Herbert S. Hamilton serving as president for many years. The plant's production output was 66,000 bricks a day, or 24 million bricks a year. (Courtesy of Jean and Clarence Ward.)

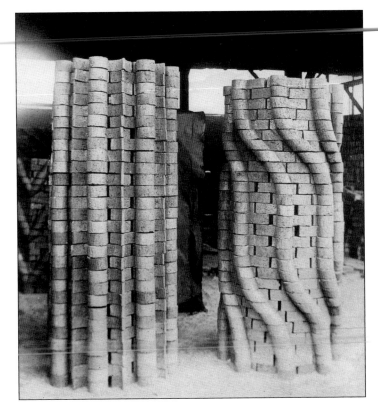

This is one of a series of postcards that shows bricks in various artistic formations at the McArthur Brick Plant. It is not known whether these formations were deliberate artwork or a creative stacking of bricks. These facing bricks were widely known, used not only locally but shipped by truck and rail throughout Ohio and to other states. (VCHGS.)

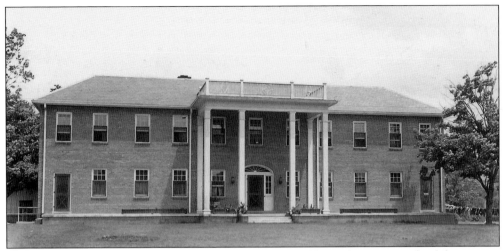

The County Home, or Infirmary, was built in 1874 for children who were wards of the county. After about 15 years, a separate Children's Home was built on the north end of the county farm. For a time, Elk Township maintained a school there, but the children later attended McArthur schools. In later years, it became the Twin Maples Nursing Home and is now the Maple Hills Nursing Home. (VCHGS.)

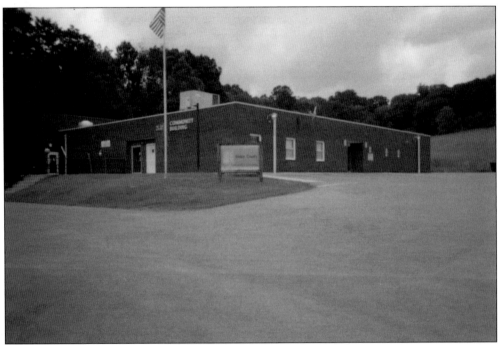

The Vinton County Community Building was the first structure in an agency complex that now includes the Emergency Medical Service and the Health Department. Built in 1974 with federal revenue sharing, the building's first occupant was the Vinton County Extension Service. An addition made room for the Vinton County Senior Citizens. The Soil Conservation Service, Soil and Water Conservation District, the board of elections, and a large meeting room are also located there. (Author's collection.)

Two

VILLAGES AND TOWNSHIPS

Although Vinton County did not exist until 1850, the land, some of the villages and organized townships, and some 9,000 persons preceded it as part of other counties. The federal government had already established several post offices, and a few townsites had been platted.

Wilkesville dates from 1810 with the arrival of Henry Duc, an agent for a Mr. Wilkes who bought a large tract of land from the Ohio Company. It became a post office in 1819, preceding McArthurstown by seven years. Other early post offices included Bolen's Mill in 1840 (on Raccoon Creek), Allensville in 1837 (first briefly Rileyville), Reeds Mill in 1828 (later Hamden Junction and Hamden), and Prattsville in 1848 (also known as Lone Star). New Plymouth dates from 1850.

The Marietta & Cincinnati Railroad, which traversed the county in 1856, coupled with the building of iron furnaces, led to the founding of other communities. Most of the furnaces were near the railroad, and little company-owned communities for workers developed around them. With one exception, Zaleski, all of these hamlets have virtually vanished. Zaleski owed its growth more to coal mining and the railroad car shops than to the short-lived iron furnace. Zaleski became the first town in the county to have more than 1,000 residents, but the relocation of the car shops and reduced mining caused it to dwindle to about 300 people. Dundas retained some size as a rail-crossing community even though the post office and groceries are gone. Ray survives with a post office and a little community. A north-south railroad crossed the county in 1880, most often called the Hocking Valley. As a result, more townsites developed, including Creola, Orland, Oreton, Minerton, and Radcliff.

Most of these communities survived the early years as secondary marketing centers, where area farmers sold their surplus produce and obtained groceries. As the horse-and-buggy era gave way to automobiles, they became less significant, and people went to larger towns. Churches and sometimes other institutions help to retain some sense of community.

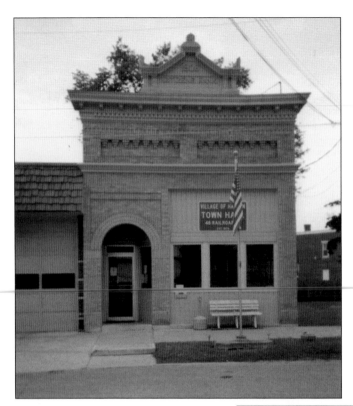

Hamden's town hall is located on Railroad Street in the old Citizens Bank Building, which was established in 1908 and closed after the Great Depression. The original name and date are still visible at the top of the building. The former fire department structure is immediately east of the village hall. A new four-bay fire department building was erected in 2007 at 100 Wilkesville Street. (Author's collection.)

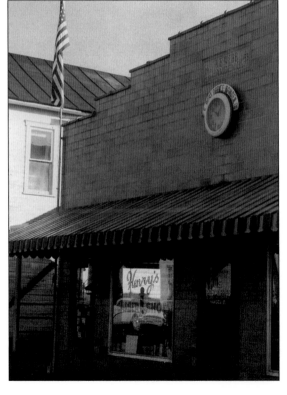

In 1953, the late A.E. "Earl" Webb had S.E. Tripp and Frank McClaskey build a Hamden post office structure on the main street. The post office continues to occupy the southern half of the building. The northern half has at times housed a barbershop and a pizza shop. (VCHGS.)

The Town Tavern, also known as the Beer Garden, is shown in a 1977 photograph. It was located for many years on the southeast corner of Buffalo and Railroad Streets in Hamden. The Hamden Community Building now stands in this location. Built and owned by the Hamden Firefighters Association, the structure was dedicated in 1987. (Courtesy of Lawrence McWhorter.)

For many decades, this structure at 80 South Main Street in Hamden housed the hall of Mineral Lodge No. 259, Free and Accepted Masons. Mineral Lodge thrived from 1855 until 2002, when it was unable to attract new officers. In earlier times, the ground floor had also been the town's Opera House. (Courtesy of Alberta DePue collection.)

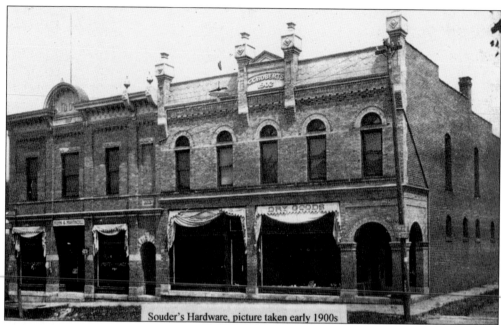

Souder's Hardware, picture taken early 1900s

Among the more imposing structures in Hamden are the Frank Roberts Block, a store that sold dry goods and other items, and the Odd Fellows Lodge Hall. Hamden Lodge No. 517 flourished from 1872 to 1934; in 1911, it had 120 members. Later, the top floor of the IOOF half was removed, and both buildings became Souders Hardware. (Courtesy of Alberta DePue collection.)

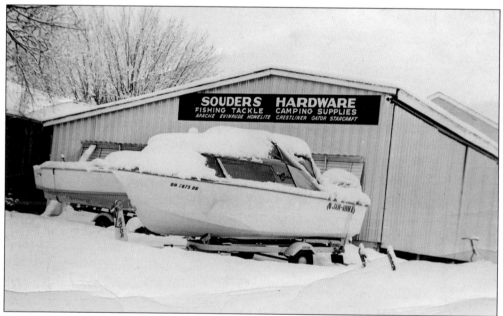

Souders Hardware in Hamden was located in the Roberts Building on Main Street. Started in 1949 by Terry and Vera Souders, the hardware business offered supplies for farm and garden as well as for sports, especially fishing, hunting, camping, and boating. Don and Lois Souders retired and closed the store in 2009. They remain active in the Hamden and Wellston communities. (VCHGS.)

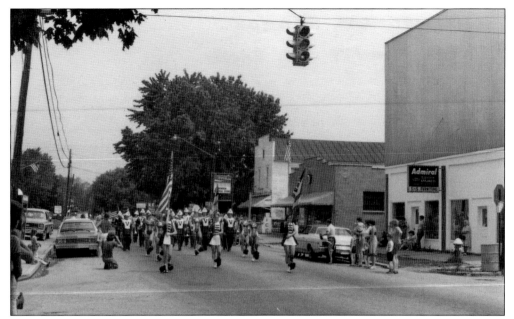

This 1979 Hamden parade scene offers a good view of the Hamden General Store, then operated by Otto and Alberta DePue, the post office, and S&S Appliance and Furniture Store. By 2014, only the post office remained, as both stores and even the traffic light are gone. (Courtesy of Lawrence McWhorter.)

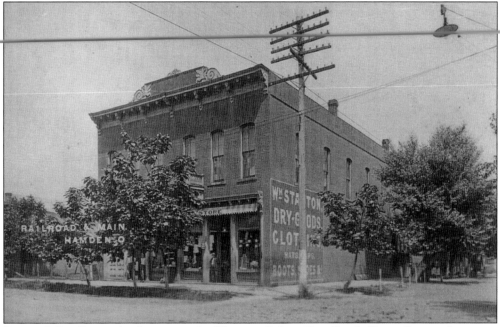

Stanton's Big Store, also known as the "Stanton Palace Dry Goods House," was a dominant structure in Hamden for many decades, beginning in 1881. It was first operated by William Stanton and then by his son Leo until the early 1950s, when he sold out to Vernon Shafer. The building burned down in 1986. In 1948, Leo Stanton described himself as a "dealer in everything." (Courtesy of John Cline.)

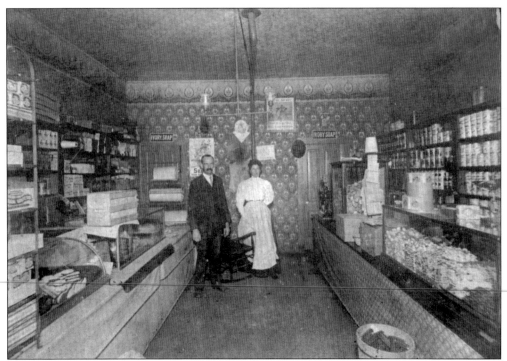

This early-1900s photograph shows the interior of Howard and Margaret Huhn's Store on Main Street in Hamden. The Huhns were relatives of Charles McCoppin, longtime Hamden mayor (approximately 27 years). Another Huhn, John, presumably a relative, had a similar store in Zaleski. (Courtesy of Alberta DePue collection.)

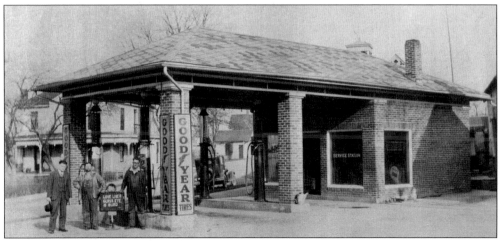

A canopy over gasoline pumps at service stations is hardly a recent innovation. Ira Salts's station at the corner of Wilkesville and Main Streets in Hamden, seen here probably in the 1930s, not only had a covered area but it sold Goodyear tires as well. Ira and friends are standing beside a sign with down-home wisdom: "Love like a glass eye is blind." (Courtesy of Alberta DePue collection.)

Little remains of the brick plant town of Puritan except for some houses and the brick Free Will Baptist Church, built in 1986. The old Puritan church pictured here was built about 1920 and was in use until the new one was erected. Puritan boasted a one-room school until the late 1940s and a store until the 1960s. (Courtesy of Lawrence McWhorter.)

Dundas, also once known as McArthur Junction, became a significant locale beginning in 1857 as a rail stop nearest the county seat. In 1880, it gained a station when a north-south rail line (usually called the Hocking Valley) made Dundas a 24/7 rail station, until 1962. The post office, dating from 1857, is seen here in 1966. (Author's collection.)

Although Wilkesville is a small village of approximately 150 people, it failed to roll over and die when its high school closed in 1966. The Wilkesville Community Center, dating from 1996, is a tribute to the cohesiveness that has characterized an area where the American Legion, Masonic Lodge, Eastern Star, volunteer fire department, and churches have helped maintain a sense of community spirit that has disappeared from other locales. (Author's collection.)

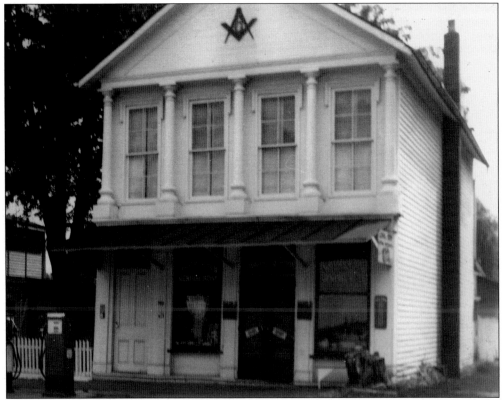

Orphan's Friend Lodge has been a significant organization in Wilkesville since 1855, and the Eastern Star has existed here since 1907. Through much of the 20th century, both organizations met on the second floor of Long's Store (pictured). In 1968, a new brick hall, still in use, was built. The old hall/store burned down soon after. In 2007, Orphan's Friend had 153 members. (Courtesy of Orphan's Friend Lodge No. 275, F&AM.)

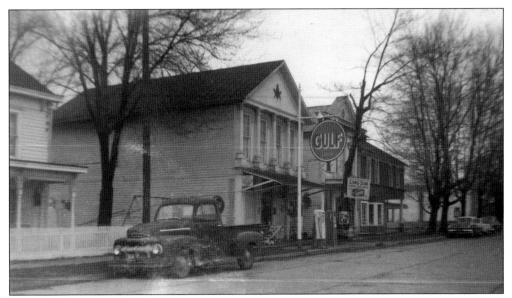

Downtown Wilkesville is seen here in the early 1960s. The building at center housed the Orphan's Friend Masonic Lodge on the second floor and Long's Grocery on the first floor. It is said that the grocer often put timbers to support the roof of the store when the lodge hall was filled to capacity. Later in the decade, these buildings burned down. (Courtesy of Ivan Tribe.)

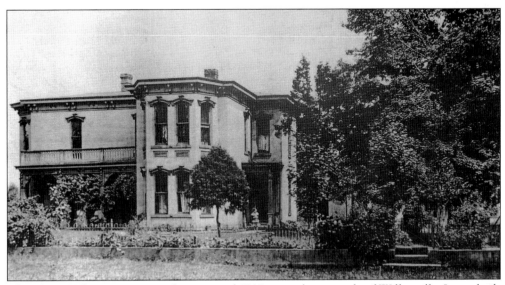

The Cline-Wells mansion, seen here around 1910, is on the east side of Wilkesville. It was built by Dr. William C. and Ruth Cline following the Civil War. After their deaths, Bundy Wells purchased the home, which has been in the Wells family since about 1900. It is currently owned by Joseph and Constance Wells White. Right of the mansion is the house where Gen. John Morgan stopped on July 17, 1863. (Courtesy of Constance Wells White.)

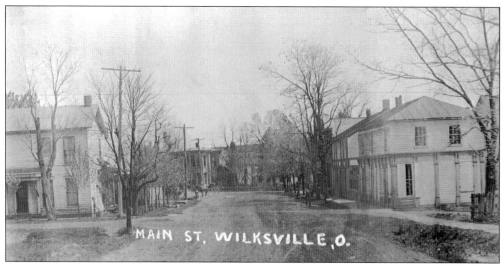

Main Street of Wilkesville is seen in this c. 1913 photograph looking east. Dr. Cline's brick house is in the distance on the left, and a wood frame house is visible at the end on the right. The house in the left foreground is still standing. All of the residences on the right have been destroyed by fire. Wilkesville's Main Street has had three major fires, which destroyed many of the original buildings. (Courtesy of Constance Wells White.)

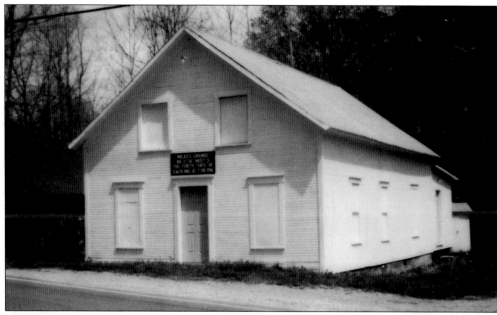

The Patrons of Husbandry (Grange) was founded in 1867 as a social and agricultural protest movement. At times, there were granges at Allensville (which never had its own hall), Green Valley near Prattsville, New Plymouth, Vinton Township, and Wilkesville Township. The latter, pictured here in 1993, still stands on State Route 124, but it closed some years ago. The membership merged with Albany No. 1611. (Courtesy of Betty Lou Wells.)

The old Wilkesville Fire Department building still stands on the southeast corner of the village square. A new building was constructed in 2012, located on the edge of the former school property at 127 North Town Street. The Wilkesville Volunteer Fire Department is very active in sponsoring community events and activities, most of which take place on the town square. (Author's collection.)

Presbyterians in Wilkesville go back almost as far as the village, with meetings held in the home of Henry Duc before a church was organized in 1820. The first edifice dates from 1828, and the second from 1874. Both of these were on the high ground near where the academy and, later, the school were located. The structure pictured here dates from 1888. (Courtesy of Betty Lou Wells.)

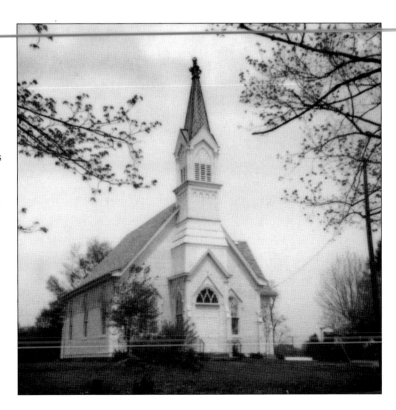

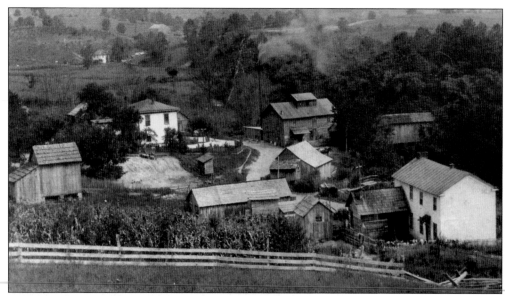

This early-20th-century photograph, taken from a hilltop, shows Vales Mills in Vinton Township. Note the covered bridge at center right, as well as various businesses. The two-story home left of center was that of undertaker Bundy Martin. Known as the Vale house, it was later the home of the Johnson family. (Courtesy of Betty Lou Wells.)

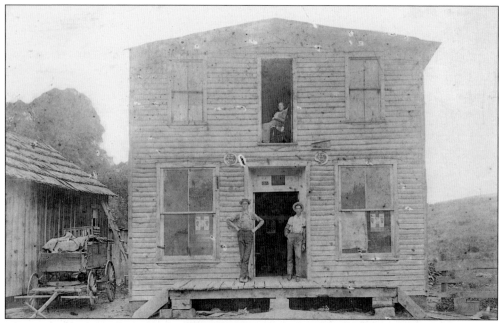

The original Vales Mill was a water-powered gristmill built on Raccoon Creek. The town of Vales Mills had a post office from 1878 until 1938. This photograph of the general store was taken about 1900. Note the elderly lady in the rocking chair on the second floor. Today, very little remains of the once-bustling community. (VCHGS.)

Zaleski's town hall dated to when the village was the largest in the county, with a population of 1,175 in 1880. Until 1874, its Marietta & Cincinnati Railroad car shops employed 240 men. After the 1874 fire, much of the work moved to Chillicothe; by 1886, all of it had relocated there. Here, the local 4-H club raises the flag for hometown day in the 1990s. The hall has since been razed. (Courtesy of Linda McKibben.)

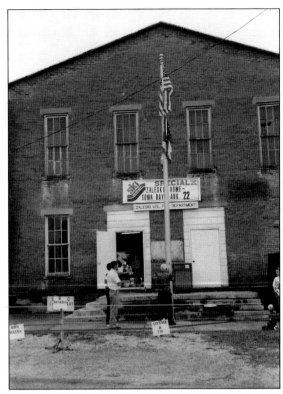

The Fischer Building in Zaleski, constructed in 1873 when Zaleski was the largest town in Vinton County, housed the Fischer family general store. The second floor was an opera house or auditorium. The top floor housed Zaleski Masonic Lodge and Eastern Star. (VCHGS.)

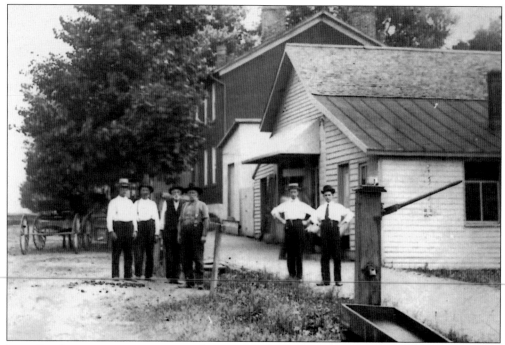

In earlier days, it was not uncommon for incorporated villages like Zaleski to have a town pump to provide water for those who lacked wells. In this c. 1900 photograph, a half-dozen Zaleski men pose near the town pump, which is very prominent at right of center. (Courtesy of Betty Lou Wells.)

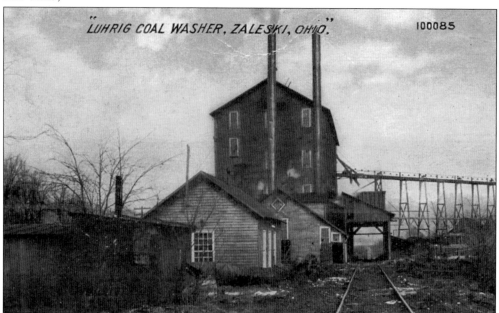

In 1897, a Luhrig coal washer (named for a German engineer who developed the process) was installed east of Zaleski. The Luhrig process cleaned about 400 tons of coal daily, removing about half the ash and some sulfur. Although long gone, the coal washer still operated in 1916. A mining camp in Athens County, on the B&O Railroad, was named Luhrig. (Courtesy of Frank Griffy.)

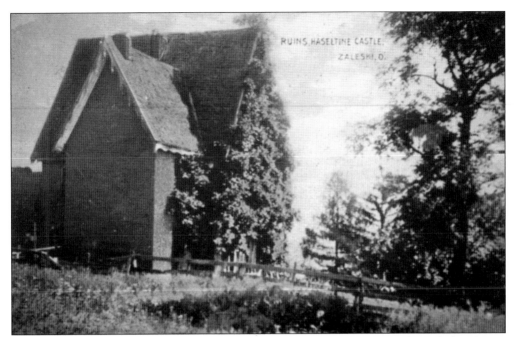

Zaleski's "castle" was built for Polish count Peter Zaleski, an investor in the Zaleski Mining Company. The town named for him was laid out in 1856 on company land. He never came to Zaleski or lived in the large home, called Haseltine Castle for the family living there. At the time of this photograph, the castle was already in ruins. (VCHGS.)

Zaleski, as an industrial town, attracted a Roman Catholic population. St. Sylvester's Parish was organized in 1867–1868. When fire destroyed the original frame church in 1929, a new brick structure (pictured) replaced it in 1930. St. Mary's Parish thrived in southern Wilkesville Township, and the smaller St. Joseph's Parish thrived for several years, beginning 1882 in Dundas. In addition, missions were established in some furnace communities. (Author's collection.)

45

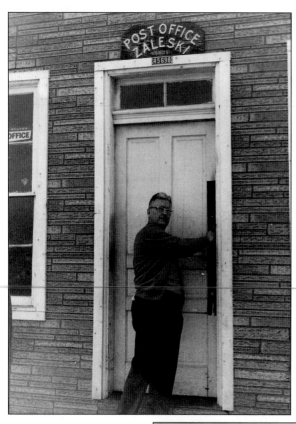

The village of Zaleski in Brown Township was laid out in 1856, and the first post office was established in January of that year. Pictured here going into the post office is Richard "Dick" O'Leary, who served as postmaster for just over 40 years, from April 1942 to October 1982. (VCHGS.)

The Zaleski Baptists were organized in January 1881 by Rev. E.W. Lloyd, and the congregation built this compact 28-foot-by-42-foot structure. By 1883, membership numbered about 100, with a well-attended Sabbath school. Originally called Mission Baptist, it later became Free Will Baptist. The church continues to hold services. Zaleski's Methodists organized in 1861, with its 1881 building on the same street as the Baptist church. (Author's collection.)

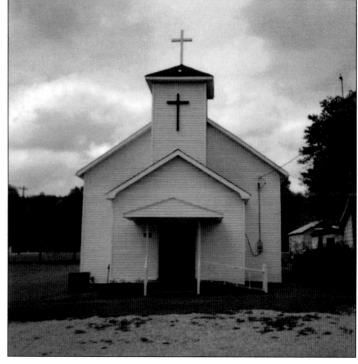

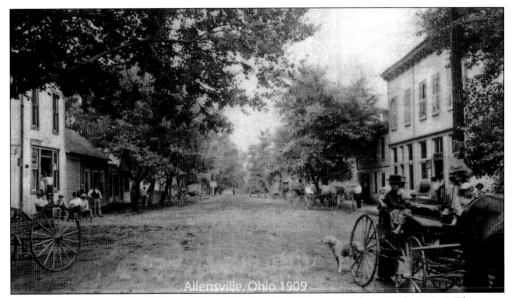

Allensville was named for William Allen, Chillicothe's US senator from 1837 to 1849. The town acquired a post office about 1840, which served western Vinton County. Allensville's business block lined both sides of the main street, as seen here in 1909. By the 1960s, businesses run by the Allens, Wilsons, and Cecils remained; they are now closed. Since the late 1970s, the Remy family has had several businesses east of Allensville. (Courtesy of the Glandon family.)

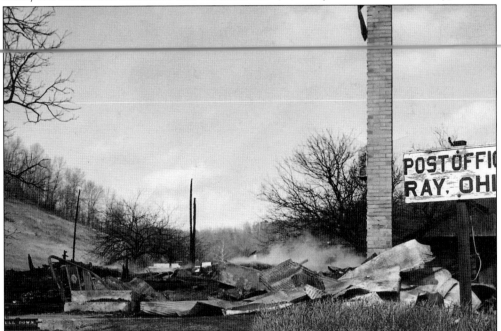

The post office at Raysville was established in 1856; the name was changed to Ray in 1893. The post office was located in the postmaster's home or in a store, changing between Jackson and Vinton Counties several times until being located in its present brick building in Vinton County in 1957. This undated photograph shows a burned-down Ray Post Office, likely a postmaster's home. (VCHGS.)

Eagle Township trustees have refurbished the township building. Farthest from the county seat, the township borders Ross County. In the early 1980s, while still in a relatively primitive condition, the building served as the meeting place for Vinton County Extension homemakers who quilted and participated in educational classes. Longtime residents Zelma Jones, Delia Peck, and Hulda Wolfe were among the attendees. (Author's collection.)

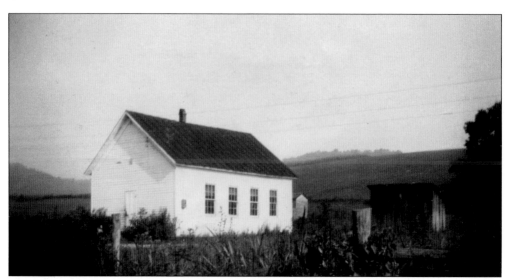

The Harrison Township building, in the western part of the county on US Route 50, is used by the township trustees for meetings, storing their equipment, and as a polling location. It was formerly the Ratcliffburg one-room school, which operated until the fall of 1951. (VCHGS.)

Miller's General Store in the hamlet of Orland on State Route 56 served the populace of northern Vinton County for decades. The grocery store with gas pumps was located in the Miller Building. Orland had a railroad station and a post office that operated from 1881 until 1938. (VCHGS.)

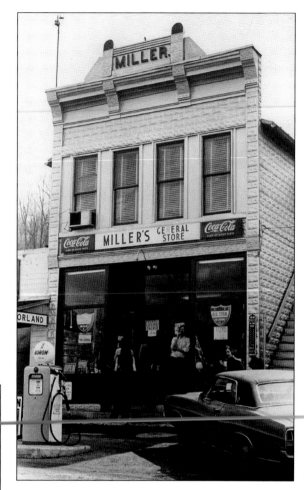

General stores were known for handling a wide variety of products, but Kirkendall's in Creola may have surpassed many in its offerings, as seen in this 1910 advertisement. A.B. Kirkendall built the store around 1885, and it was operated by several other proprietors before Arlene and Harold Ward ran it for 25 years. They closed the grocery store for good in 1989. (VCHGS.)

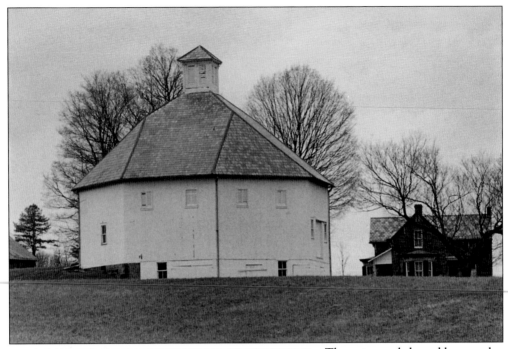

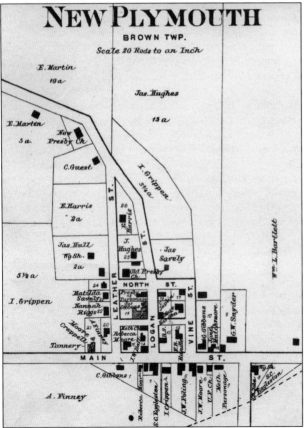

NEW PLYMOUTH

BROWN TWP.

Scale 20 Rods to an Inch

The octagonal-shaped barn and two-story stone house located on Shurtz Road in Swan Township are architecturally unusual, especially considering the mainly local materials from which they were constructed, including large blocks of sandstone. The homestead, built in 1882, still looks much the same. Dating from about 1885, the barn has a sandstone foundation; the cupola in the center acts as a ventilator. (Author's collection.)

New Plymouth, established as a post office in 1850, had about 150 residents in 1883 and two flourishing churches, Methodist and Presbyterian. In 1875, when this map was made, New Plymouth had two general stores, operated by James Gibbons and Seth C. Eggleston. The hamlet in Brown Township also had a tannery. (VCHGS.)

Three

BUSINESS, COMMERCE, AND INDUSTRY

Besides subsistence agriculture, the early economic base of what became Vinton County was buhrstones, which were used in steam-powered and water-powered mills for grinding grain. With the passing of time, this form of primitive industry declined from its early significance.

When Vinton County was formed, geologists viewed the area as a source for natural resources, particularly coal, iron, and timber. Coal's importance increased with the coming of the Marietta & Cincinnati Railroad, and small mines opened in such hitherto inaccessible locales as Ingham, Moonville, vanished Elko, and Zaleski. Railroads stimulated demand for iron rails, locomotives, freight and passenger cars, and other railroad equipment. Locomotives burned large amounts of coal. Vinton County's economy soared for 30 years. The county never became a major coal region. Annual production never surpassed a million tons until the 1970s, when underground and surface mining thrived. The charcoal-fueled iron industry declined with development of the great iron ranges in the Lake Superior area.

Forest industries maintained a strong economic base in the county, although the business shifted from small operations. For example, Baker Wood Preserving Company employed over 100 workers in the 1950s. Bricks were another natural-resource industry. The McArthur Brick Company flourished for nearly 60 years. Another brick plant was located in Puritan, with smaller plants and potteries dotting the county. In 1939, the Cleveland-based Austin Powder Company started its Red Diamond Plant not far from where Elko had once flourished. Austin produced dynamite and other explosives. Although the nature of the product has changed, Austin Powder remains a major county employer.

Business also includes retail establishments. Country general stores were once common, and small towns had a variety of shops, but changing times have caused most to close. Cross Creek General Store is an exception. Remy's Mobile Homes and their other businesses east of Allensville continue to be successful. Standard Hardware and Supply is about the only longstanding independent business. The villages have convenience stores that sell gasoline and a limited line of groceries.

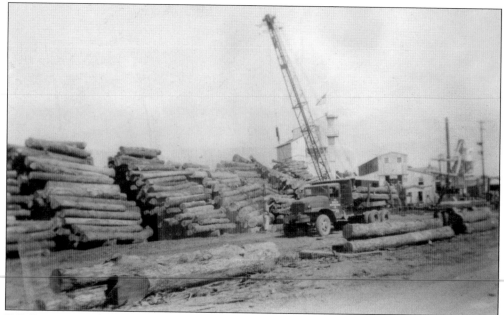

D.B. Frampton and Company had a subsidiary lumber operation in McArthur from the mid-1940s until closing in 1962. At one time, it had the largest sawmill in Ohio and owned more than 75,000 acres of land. The Crownover Lumber Company has operated for many years on the same site as this previous Baker Wood Preserving Company. (Author's collection.)

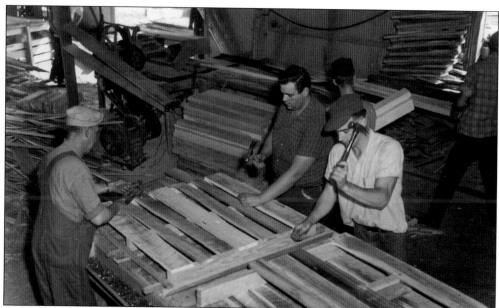

Woodrow Jeffers, who worked in timber for more than 50 years, operated a pallet company in Dundas. Pallets became important after World War II as flat structures to support goods while being lifted by forklifts, front-end loaders, and other lifting devices in preparation for shipping. These were often made of softwoods or "rough" lumber. This photograph was taken in 1964. (VCHGS.)

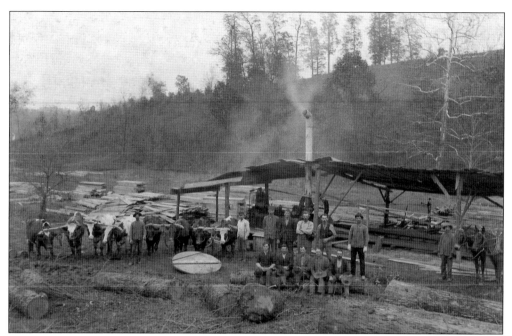

This 1920s photograph shows a logging and saw-milling operation that made use of yoked ox teams as beasts of burden. Steam engines powered the sawmill, and the sawed lumber was piled in the rear. This is undoubtedly a posed photograph, as the oxen, their drivers, and the workers are all neatly lined up. (VCHGS.)

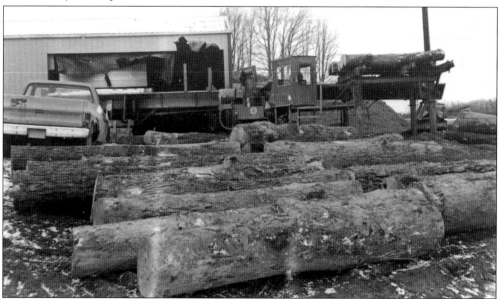

Glandon Logging, seen here in 1984, was located south of McArthur. Bob Glandon retired, and another owner continues the timber business. For about 40 years, in addition to Glandon, there were several major sawmill operations along State Route 93 and in McArthur, including Adelmann and Clark, Jeffers Pallet Company, Waldron Lumber, Mercer Sawmill, Industrial Timber and Land, McArthur Lumber and Post, Baker Wood (later Crownover Lumber), and Twin Oak Forest Products. (Author's collection.)

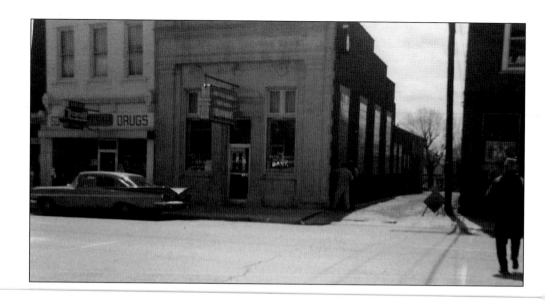

The oldest continuous business in Vinton County is Vinton County National Bank (VCNB). The original institution, known as Will, Brown, and Co., was organized in January 1867. Consolidating more than a year later with another banking firm, it operated as Vinton County Bank until October 1872, when it became a national bank. There has been a Will family member in prominence since its beginning, and it has been in the same location. Remodeling, adding new technologies like drive-through banking, branch offices, and expansions with offices in six other counties have resulted in a modern financial institution with friendly service. The VCNB is seen above in early 1964. The popular Gorsuch Drug Store next door was purchased for bank expansion in 1980. The bank's very open front lobby area is shown below in the early 1960s. (Both, courtesy of Vinton County National Bank.)

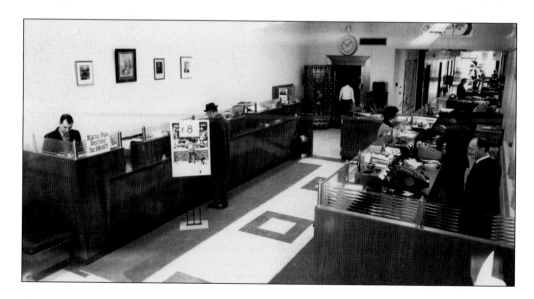

This remnant of Hope Furnace from the charcoal iron industry of the 1860s–1880s still stands near Lake Hope on State Route 278. The site is maintained by park staff. On-site signage details the furnace's history and ore-making process. The stone stack was originally surrounded by several wood structures. Vinton County once boasted six such furnaces. (Author's collection.)

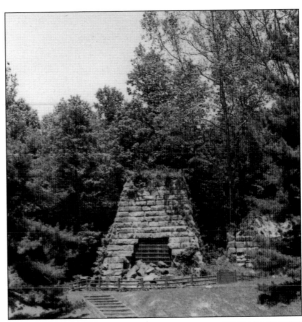

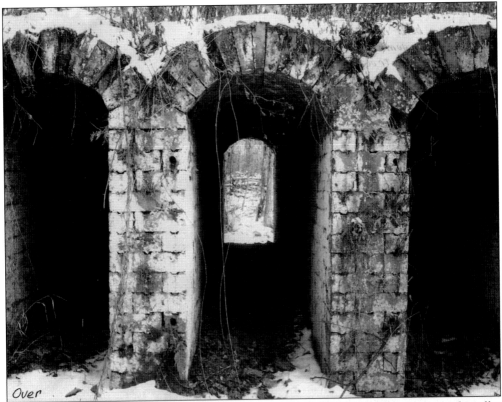

Vinton Furnace dated from 1853. It had a daily capacity of 12 tons, a railroad spur, and a taller stack than the other charcoal furnaces. In 1868, its management unsuccessfully attempted to convert to coke to fuel the furnace and built the Belgium ovens, the ruins of which are pictured here. In peak years, the furnace community contained about 44 houses. (VCHGS.)

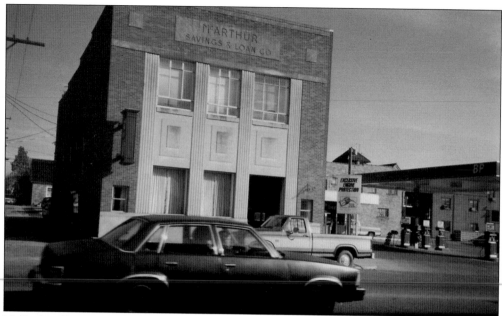

McArthur Savings and Loan Company was established in January 1889 on West Main Street. A quarter of a century later, its assets reached $315,000, and about one third of the town's population were stockholders or depositors. In 1989, it became Unity Savings and Loan Company of Southeastern Ohio, which was acquired by Oak Hill Banks in 1997. In 2007, Oak Hill Banks merged with WesBanco based in Wheeling, West Virginia, and the original McArthur Savings and Loan became the McArthur branch of WesBanco. Last names of some early directors included Sprague, Pilcher, Paffenbarger, Darby, and Knox, the latter name continuing with the business through recent times. The building shown in these photographs likely dates to the mid-1940s. The above image was taken about 1990, and the one below was taken a few years later. They give some indication of the adjacent businesses, including Sohio and BP stations and a Laundromat. None of these businesses currently exist. (Both, courtesy of D. Bruce Knox.)

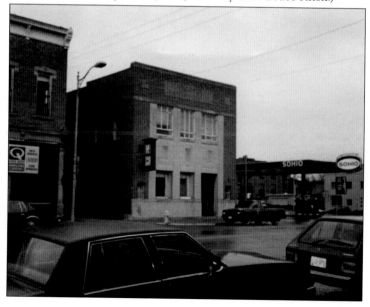

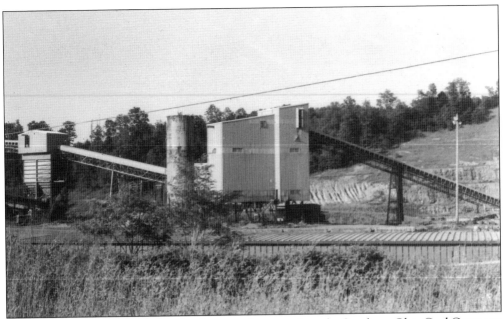

The 1970s saw a revival of the coal industry in the area when the Southern Ohio Coal Company opened three large captive mines. No. 1, near Salem Center, and No. 2, at Point Rock, were in Meigs County. Raccoon No. 3 in Wilkesville Township is pictured here. These mines supplied fuel for electric power plants in Gallia County. (Author's collection.)

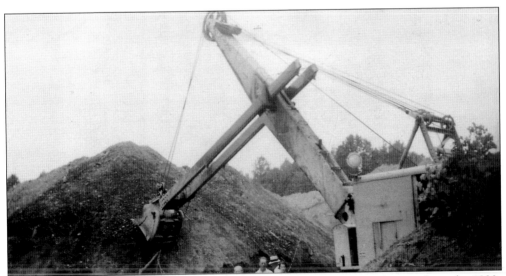

Surface or strip-mining of coal made an economic impact in Vinton County from the 1930s onward, notably by Benedict, Inc. in Swan Township. There were other such operations as well, some continuing to the present. This 1939 photograph captures such an operation. Note the size of the strip-mine shovel. (VCHGS.)

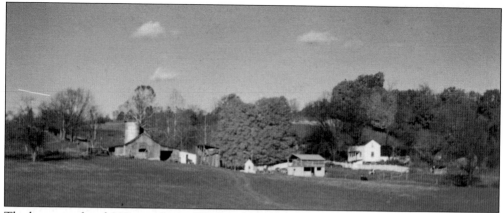

The homestead and 300-acre farm of Fred and Laura Jarvis, seen here in 1953, was located one and a half miles south of McArthur on Frazee Lane. Their diversified farm included a Jersey dairy operation selling and shipping bulk milk. They were early practitioners of strip-farming, built a farm pond, planted pine trees, and mined coal that lay under the farm. The Jarvises were active in community activities. (Courtesy of Rose Ann Jarvis Bobo.)

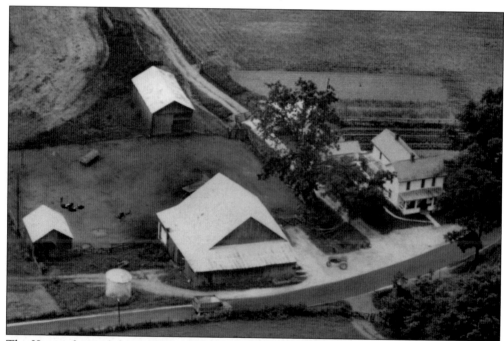

The Kruger farm of about 475 acres, located north of Allensville near the Mt. Olive covered bridge, has been in the family since 1875. It was recognized as an outstanding Century Farm in 2002. Beginning in the late 1920s, twin brothers Roy and Raymond lived, worked, and reared their families together in the large farmhouse. It is still an active farming operation in the Kruger family. (Courtesy of Mary Kruger Downard and Rita Kruger Teeters.)

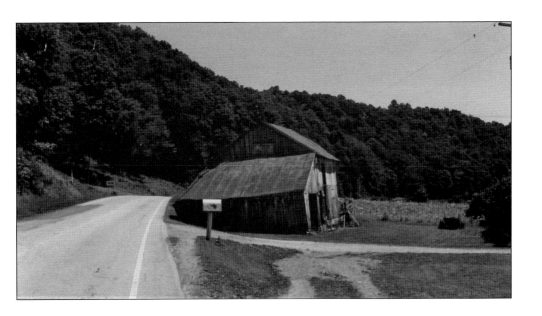

The barn at the Ben Gearing farm west of Allensville (above) is no longer standing, but it served the needs of the farm operation, primarily crops, for many years from about 1948. The farm, in productive bottomland, remains in the Gearing family. Pictured below are Solomon (left) and brother Ben in 1927 as young adults working on the family farm on Gearing/Graves Ridge. The Gearings had relocated to the Allensville area from Arkansas in 1921, traveling in a Conestoga wagon. (Both, courtesy of the Gearing family.)

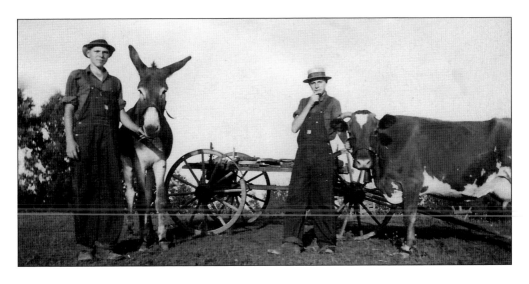

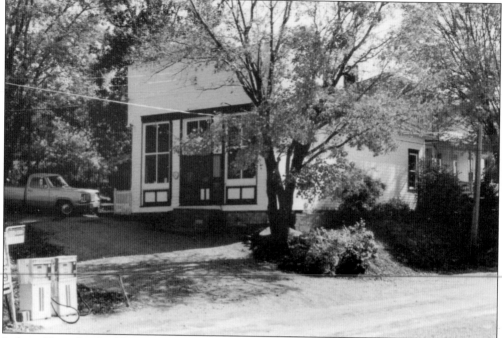

Jackson Township had hardly any establishment big enough for it to be termed a hamlet, and its last post office closed in 1907. But for nearly a century, it had a country store on Locust Grove Ridge, built and operated by T.C. Fox from 1898 until 1924. For the next 63 years, it was run by Cliff Fout, his son Langley, and Langley's wife, Helen. (VCHGS.)

Engle Construction Company in McArthur started out in the 1950s with one or two trucks. It has expanded into a business that built part of the Ohio Appalachian Highway and the Logan intersection at Routes 33 and 93. Eugene Engle has also operated Benedict Mining and formerly owned Diamond Stone. Pictured are employees at the annual reunion in 2000, an event that continues to this day. (Courtesy of John and Connie Staneart Largent.)

Austin Powder Company's Red Diamond plant near McArthur opened in the early 1930s. It is Austin's core manufacturing operation for industrial explosives, blasting agents, and accessories. Its products are shipped throughout North America and to Austin's international sites. Visitors to the Crazy Horse monument in South Dakota can see the Red Diamond materials in the display case. Here, Red Diamond plant employees pose in January 1963. (Courtesy of Alberta DePue collection.)

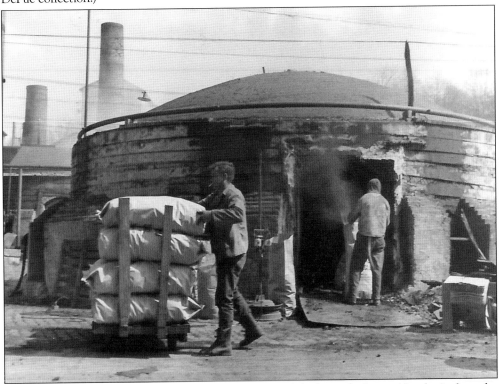

The abundant clay in Vinton County and its weathered shale resulted in red brick. At first, the bricks were manufactured at the site where building occurred. There were quite a few brick plants, including in Harrison and Brown Townships, Zaleski, Hamden, Puritan, and the more modern McArthur Brick Company, where workers are at a kiln in the late 1950s. (VCHGS.)

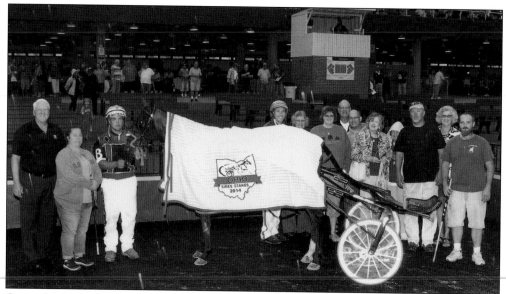

Crown Time Keeper is seen after winning a race at Scioto Downs in Columbus. In the early 1980s, Esther and Leo Crownover, of the Crownover Lumber Company in McArthur, began a hobby and business in Standardbred horse racing and have had a large stable of "Crown Time" horses over the years. Other local families with racehorses include Frank Johnson, Earl Owings, and Mike Sowers. (Courtesy of Esther Crownover.)

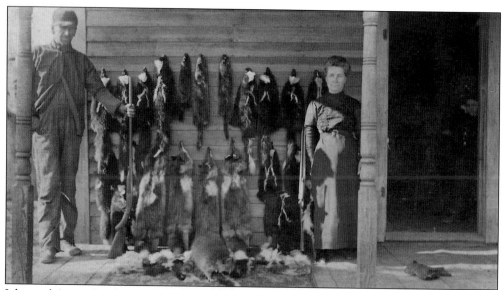

John and Anna Quick pose with pelts and furs hanging to dry before being sold, representing a successful trapping season in northeastern Vinton County. This was a fairly common means for country people to make money. Muskrats, minks, raccoons, and foxes were more valuable; skunks and opossums less so. (Courtesy of John and Connie Staneart Largent.)

Bowen's Store, about 10 miles east of McArthur on US 50, was a Knox Township landmark from the 1940s to about 1970. It sold gasoline and groceries, kept cold with a kerosene refrigerator. Bob Meek operated the business prior to Bowen ownership beginning in 1948. After Maude Bowen died in 1968, a niece ran the store for a time before it closed. This photograph dates from about 1950. (Courtesy of Betty Lou Wells.)

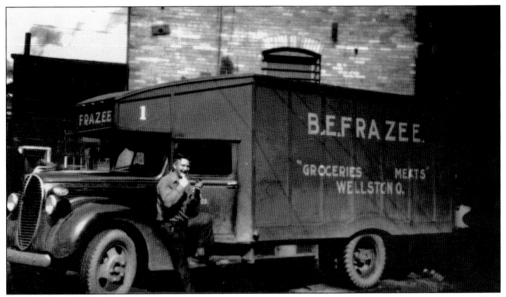

For many years, Frazees in Wellston operated a "rolling store" in the Hamden area. There were two other rolling stores in Vinton County: Fout's on Locust Grove Ridge and Allen Brothers in Allensville, which operated into the 1960s. These rolling stores, usually in refurbished school buses, carried basic foodstuffs and accommodated their customers' needs. They had regular routes and ran five or six days a week. (Courtesy of Alberta DePue collection.)

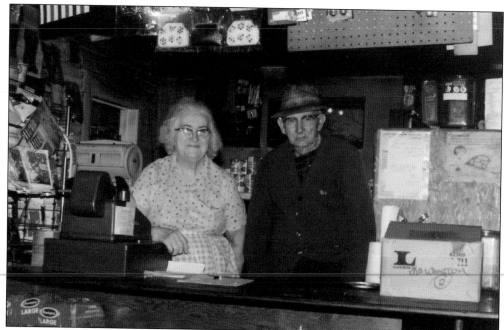

Floyd and Dorsa McWhorter of Hamden pose in their neighborhood grocery on Stanton Avenue in the mid-1980s. They were in business for about 50 years, selling a full line of grocery items seven days a week, from 6:00 a.m. to 10:00 p.m. The store closed after Floyd's death in 1987. The building, still standing, is now a residence. (Courtesy of Lawrence McWhorter.)

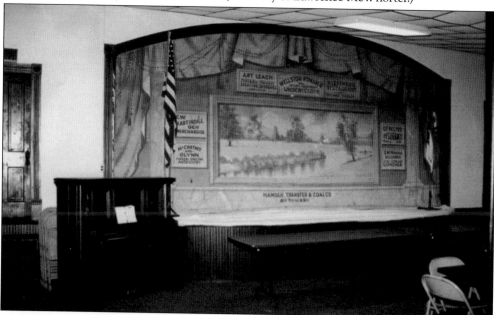

The building that formerly housed McDonald's Auction House in Hamden was for many decades the home of Mineral Lodge No. 259. The opera house was on the ground floor. The stage area (pictured) had interesting advertisements of historic local businesses, like E.W. Martindill's General Merchandise, S.W. Monahan's Billiards, and Abe Young's Hamden Transfer and Coal Company. (Courtesy of Lawrence McWhorter.)

Four

CHURCH, SCHOOL, AND SOCIETY

Religious activity was not widespread among the earliest settlers, but churches managed to flourish, gain a foothold, and play a part in the maturation of society. Methodists and Presbyterians had become organized in the Wilkesville area long before that township was incorporated into Vinton County. Methodists became dominant in the villages and the countryside. The Methodist Episcopal form of church governance prevailed, although several congregations outside the towns opted for the Methodist Protestants until they merged in 1939.

Other denominations acquired followers, especially the United Brethren (somewhat atypical since German influence was minimal) and those inspired by the followers of Alexander Campbell (more formally known as Christian, Church of Christ, or Disciples). Roman Catholics and Baptists made inroads in selected locales, while Quakers, Anglicans, and Reorganized Latter Day Saints had small pockets of influence. In recent years, with Methodist abandonment of small rural churches, nondenominational congregations have sprung up to fill the void, along with newer groups, such as the Assembly of God.

One-room district schools became the principal arm of education through much of the 19th century. Wilkesville and New Plymouth boasted academies. By 1926, McArthur, Hamden, Wilkesville, Zaleski, and Richland, Vinton, and Swan Townships had four-year public high schools. Eagle, New Plymouth, and perhaps Dundas had two-year high schools. Consolidation eliminated Eagle, New Plymouth, Swan, and finally Vinton in 1950, merging it into Wilkesville and creating Wilton. In 1942, twenty-six one-room schools remained; all had closed by the early 1950s. High schools merged into one in 1966, but it was 2000 before a new countywide high school building was put into operation, just west of McArthur.

Other social institutions included fraternal orders, granges, and veterans' groups. Among these were Masons, Odd Fellows, Knights of Pythias, and Fraternal Order of Eagles. By the early 20th century, most had affiliate groups for women. The same was true for the Grand Army of the Republic and later the American Legion and the Veterans of Foreign Wars. Together, church, schools, and organizations did their part in building the community that is Vinton County.

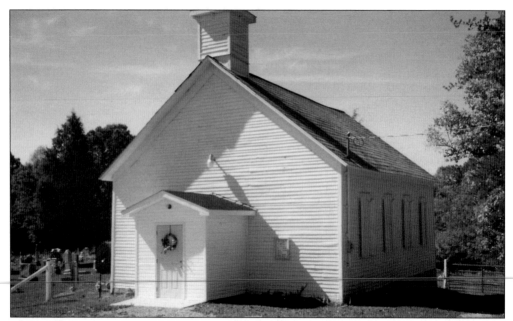

Mt. Zion Church in Richland Township was organized in 1843. The current edifice was built in 1888. Rev. Alfred Tripp, who was ordained in the church in 1938, for many years pastored the United Brethren charge. Over the years, services have been held through a variety of independent denominations. Members and friends previously returned to the Mt. Zion Church for the annual late-summer homecoming. (Author's collection.)

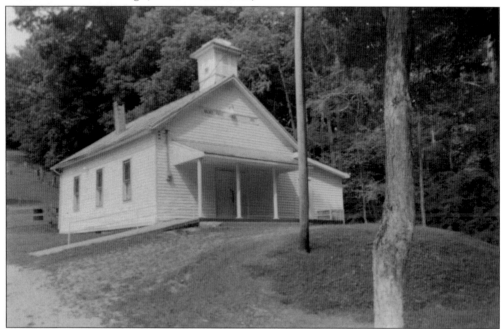

Walnut Grove in western Jackson Township was one of several Methodist Protestant churches when it was built in 1892. After the Methodist merger and the reduction in the number of churches, Walnut Grove was sold in 1966 and subsequently became Bible Christian. A cemetery is located on the steep hill behind the structure. (Author's collection.)

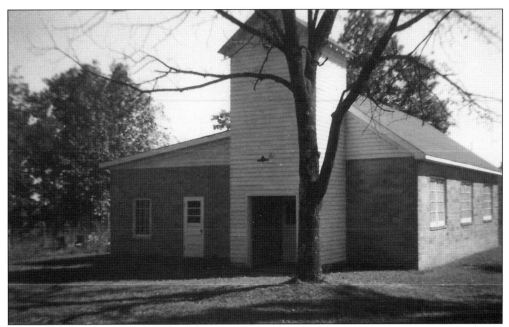

The Union Ridge Church of the Nazarene in Knox Township dates from 1949. It is in a locale that has had a small population and several other churches nearby. Nonetheless, it has flourished for 65 years, and the congregation has made notable improvements to the structure since this 1959 photograph. (Courtesy of Ivan Tribe.)

The United Brethren Church generally flourished in areas with a large German-American populace. Vinton County had few Germans but many United Brethren congregations. Weaver Chapel in Knox Township dates from 1886. In 1946, the United Brethren Church merged with the Evangelical church to create the Evangelical United Brethren (EUB). Long abandoned, the church has become a private residence. (Courtesy of Ivan Tribe.)

Harkins Chapel, another of several United Brethren churches in Vinton County, dates from 1880. It is seen here in 1959. After the Evangelical United Brethren denomination merged with the Methodists in 1968, the United Methodists dropped many of their smaller rural churches. Harkins Chapel survives independently, and the adjacent cemetery is well maintained. (Courtesy of Ivan Tribe.)

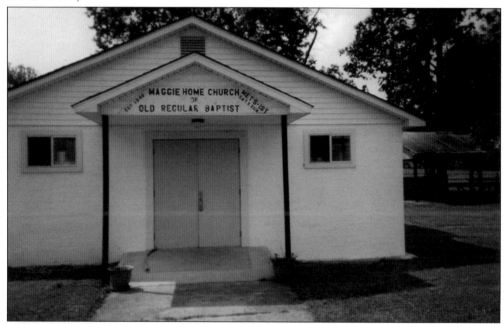

Old Regular Baptists are a small denomination especially associated with the Appalachian Highlands and migrants from there. With their movement from the mountain regions into Ohio, including Vinton County, churches such as Maggie's Home in Dundas have come into being. Their numbers are small but dedicated, and a congregation has met here since 1949. (Author's collection.)

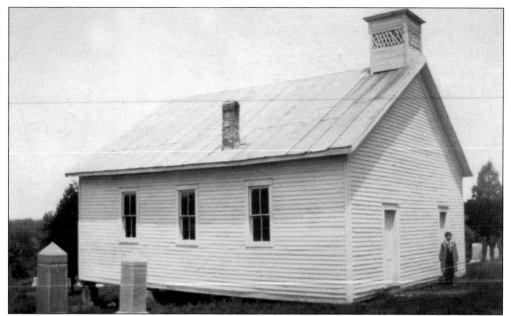

Fairview Church in Harrison Township dates to 1867, when it was built on a hill of the same name. Originally a United Brethren congregation, it subsequently became Methodist and, eventually, the independent Fairview Community Church. For some years, beginning in 1928, revivals were held in a nearby grove that attracted crowds of 300. In recent years, it has undergone some modernization. (Courtesy of Nyla Timmons Holdren.)

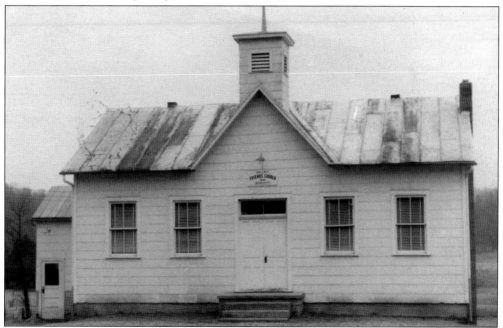

Boblett Friends Church, dating from 1906, was originally associated with the Quaker settlement at Gillespieville or Londonderry a few miles to the west in Ross County. In 1919, average membership was reported at 53 and increasing. By the late 1970s, aural evidence suggested the members no longer strictly adhered to the traditional Quaker practices. (VCHGS.)

Pleasant Valley Holiness Church on old Route 50 was built in 1950 at a cost of $6,801.86; Pleasant Wills managed the construction. Raymond Detty donated the property, and Clarence Graves donated the church bell, which was from the Old Tabernacle at Ray. The largest Sunday school attendance was 208 in 1953–1955, and the congregation operated a church bus. Many improvements have been added to the church, which is still in operation. (Author's collection.)

Pleasant Valley Trinity Church is located on old Route 50 in Harrison Township. Most recently affiliated with the United Methodists, the church has, within the past couple of years, become nondenominational as Trinity Church. Jim Taylor has been pastor for about a decade. The original church (with the steps and steeple) is at left, and the addition (right) serves as a fellowship hall. (Author's collection.)

Since this photograph was taken, Randerson Church has fallen down and been removed from the site. The unmarked cemetery is located at the end of Randerson Road, which can be accessed from State Route 683 in Richland Township. Among the tombstones, the earliest death is of an infant in 1864; the most recent burial took place in 1993. (VCHGS.)

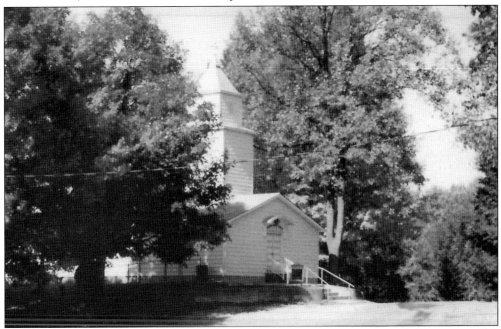

Locust Grove Church on Locust Grove Ridge in Jackson Township is near the former Fout's Store, both landmarks in the area. The congregation started with a log church, but a frame structure soon replaced it, was remodeled in 1882, and has since experienced some updates. It is seen here in 1983. There is a well-maintained cemetery adjacent to the church. (VCHGS.)

Shiloh Grove in Richland Township on State Route 683 is the site of the annual Richland Township Homecoming, which began in 1919 and apparently ended in 2013. The shelter house is located between the Darby one-room school and the Shiloh Church and cemetery. The Richland Township Memorial Association managed the area and organized and conducted the event. The shelter house was demolished in 2014 and is being rebuilt. (Author's collection.)

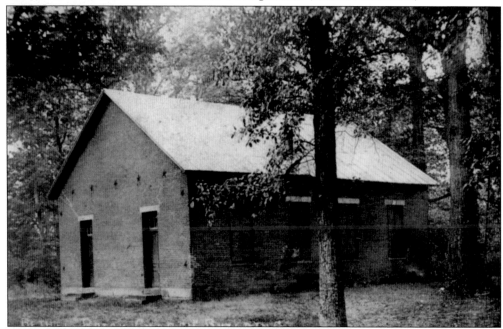

The first Disciples of Christ log church was built in 1830. Since that time, four structures have stood at the site of Bethel Church on State Route 93 south of Dundas. A frame building was erected in 1865, but it soon burned down, prompting members to construct this brick edifice in 1866. The building met their needs until 1909, when the present structure went up. The Bethel congregation praised the Lord in song, but no instrumentation was permitted. (VCHGS.)

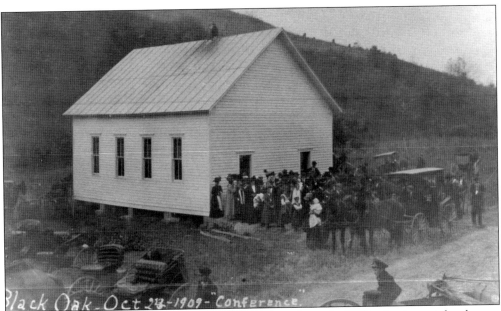

This church in northern Vinton Township dates from the early 1890s. At times, it has been a United Brethren in Christ, Radical United Brethren, and a Baptist church. Baptists, shown here in 1909, called it Black Oak; the United Brethren called it Boring Chapel. Services continue to be held in the church, now known as Black Oak Freewill Baptist Church. (VCHGS.)

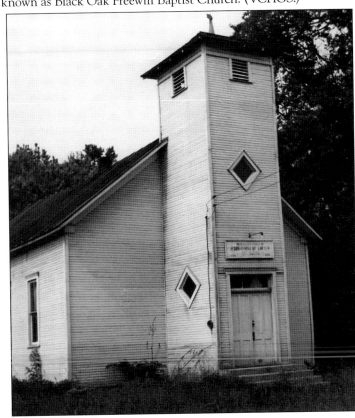

The Reorganized Latter Day Saints once had churches in both Creola and Vales Mills (pictured). The Creola church, organized by A.B. Kirkendall, was known for its special painting. The Vales Mills church dates from 1886. C.B. Wells served as one of its last ministers. A brick structure was built in McArthur in 1965. The current church is known as Community of Christ. (Courtesy of Betty Lou Wells.)

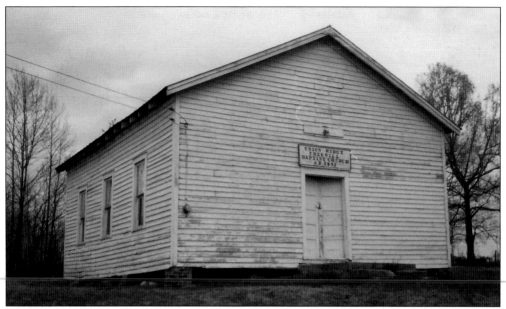

The Bean Hill Freewill Baptist Church, built in 1891, is located in a rather lonely spot in southeast Knox Township. The church still stands in a ramshackle condition, having been abandoned for some years as of 2014. The adjacent cemetery is well maintained. (VCHGS.)

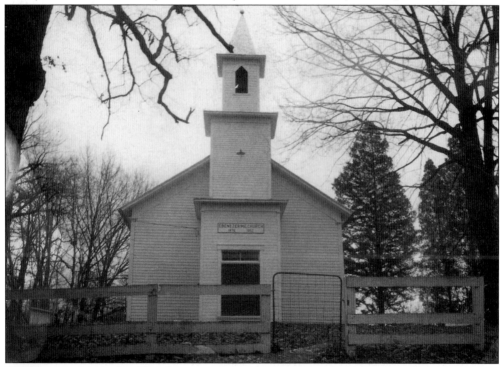

The Ebenezer Methodist Church congregation in Swan Township dates from 1849; the current structure was built in 1876. Members added a belfry and vestibule in 1901. The Hainsworth and Huggins families have a long history of activity in the church. In 1919, membership totaled about 50. Bart Ankrom is the current pastor. (Courtesy of the Vinton County Extension Office.)

In 1830, the Methodists split into two branches: the Methodist Episcopal and Methodist Protestant. Putnam Chapel, established in 1881, was of the latter type. It stands on a hill just within Madison Township and is now nondenominational. Harrison Starr has served as minister in recent years. This photograph dates from 1959. (Courtesy of Ivan Tribe.)

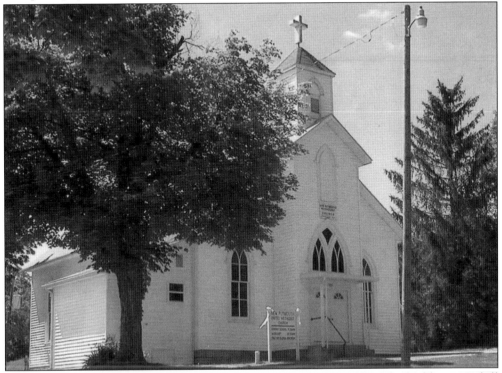

The New Plymouth Methodist Church congregation dates from 1856. The building on a hill was constructed in 1859. It has enjoyed a more or less continuous operation since that time. The present pastor is Gloria Ankrom. New Plymouth also once had a Presbyterian church. Named for Plymouth, Massachusetts, New Plymouth is the only village in Brown Township. (VCHGS.)

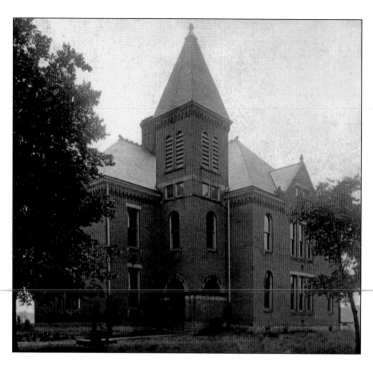

This school building served the educational needs of Hamden, beginning in 1887. Torn down in 1973, it had not been used for several years before the dismantling took place. School consolidation occurred in 1966, with high school students attending Vinton County High School in McArthur. An elementary school remained in Hamden until 2007, when it was replaced with South Elementary, just north of Hamden. (Courtesy of Alberta DePue collection.)

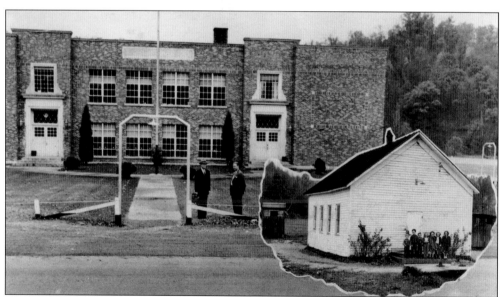

The Richland Rural High School building, dating from the mid-1920s, was in use for secondary education until the construction of the new Allensville High School, which opened in the fall of 1962 (since demolished). This photograph shows longtime school superintendent E.B. Webb (right) and principal and teacher Rodney Frye. The inset shows an older one-room school building. (Author's collection.)

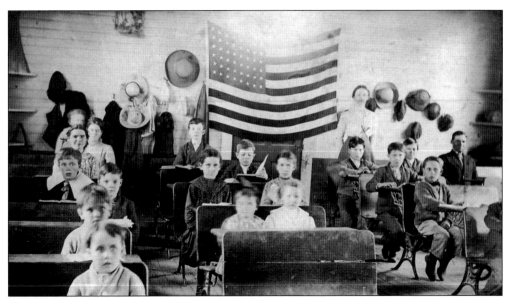

Until 1928, the children of east central Knox Township attended Lively Ridge School, after which time the students of Lively Ridge went to Picnic Grove School. Among the children pictured here are Alva and Bessie Quick. The two-seater wooden desks, coats and hats hung on the wall, and the big 48-star flag may have been common in rural one-room schools. (Courtesy of John and Connie Staneart Largent.)

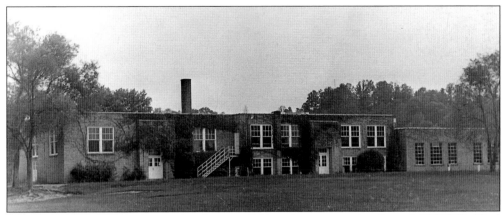

Vinton Rural High School opened in January 1934, replacing an earlier frame building that had burned down in 1930. The earlier high school became a first-grade (four-year) school by the fall of 1925. Vinton Rural served township youth until 1951, when it was consolidated with Wilkesville to become Wilton and then Wilton North Elementary for several years. It stood abandoned and dilapidated in 2014. (VCHGS.)

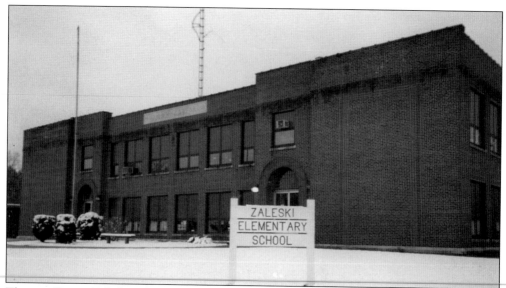

The new Brown-Zaleski School was dedicated on Labor Day 1939 and opened for students the following day. Eventually, all the one-room schools in Brown, Knox, and Madison Townships were incorporated into it. The building housed a high school as well through 1966, most of the time with Kenneth Leach in charge. It continued as an elementary school through the early years of the 21st century. (Courtesy of Betty Lou Wells.)

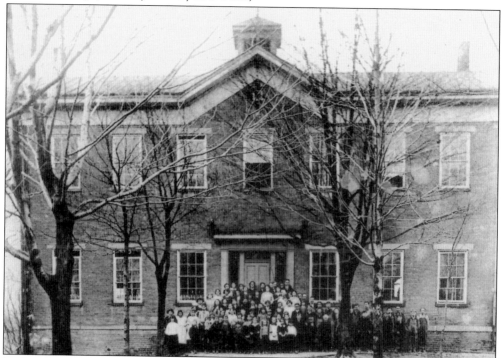

From 1872 until 1939, Zaleski schoolchildren received their formal education in this four-room (later six-room) brick building on the northwest corner of Broadway and Commercial Square. It also housed a high school from 1884. From 1890 through 1939, there was always a graduating class. In 1924, Zaleski became a first-grade high school. (Courtesy of Betty Lou Wells.)

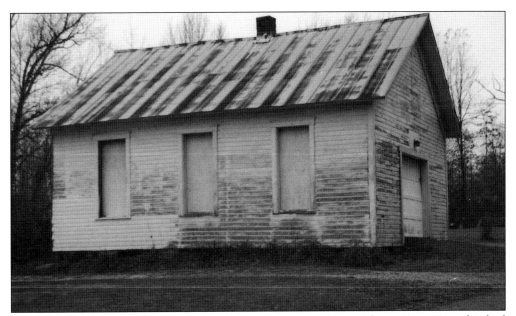

By the time of this 2003 photograph, Van Bibber School on Union Ridge in Knox Township had long ceased being used for educational purposes. Some of the family names attending the school in the early 1920s were Canode, Dixon, Huston, and Townsend. The building still stands and has been converted into a garage. (Courtesy of Betty Lou Wells.)

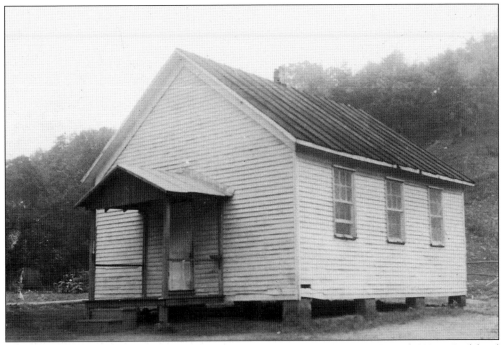

Riley School, pictured here in 1934, stood near the junction of Routes 50 and 683 in Richland Township. Edith Hoffman began her education in this one-room school and subsequently started her teaching career in the same school. One-room schools began to be phased out in the 1920s but survived in some townships until 1953. (VCHGS.)

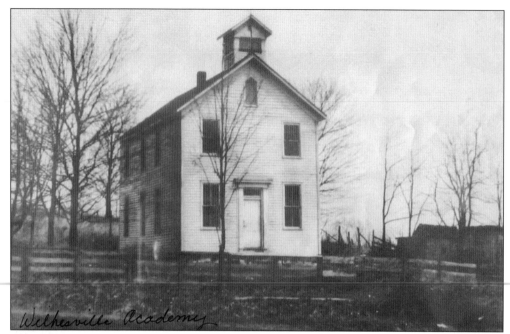

Wilkesville Academy

The Wilkesville Academy, facing the upper end of the public square, was built in 1866 largely through the efforts of Rev. Warren Taylor, who pastored the local Presbyterian church from 1865 to 1876. Money for its construction was mainly raised in the vicinity. It attracted students from a wide area and turned out schoolteachers. Later, the academy merged with Wilkesville High School. (Courtesy of John Cline.)

Picnic Grove School was one of the last operating one-room schools in Knox Township. This 1931 photograph shows teacher Mary Jeffers and her 15 pupils and their families, bearing such surnames as Beckley, Dickson, Jordan, and Staneart. Picnic Grove had earlier been called Seldom Seen and was moved to its location near US Route 50 a few years prior to this photograph. (Courtesy of John and Connie Staneart Largent and Paula Staneart Pickens.)

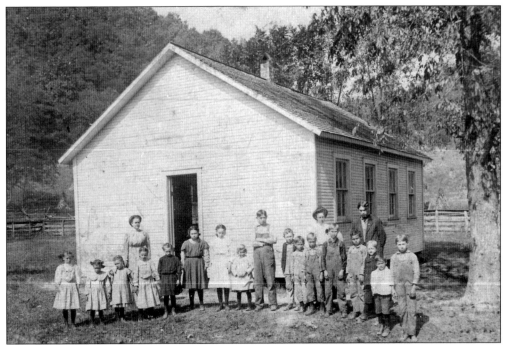

Ray or Huffman School No. 9 in Harrison Township is seen during the 1909–1910 school year. It is an example of a rural one-room school. Surrounding the structure are trees, hills in the background, and a wooden fence. The era is evident by the dress and hairstyles of the teacher and the pupils, who are of various ages. (Courtesy of Nyla Timmons Holdren.)

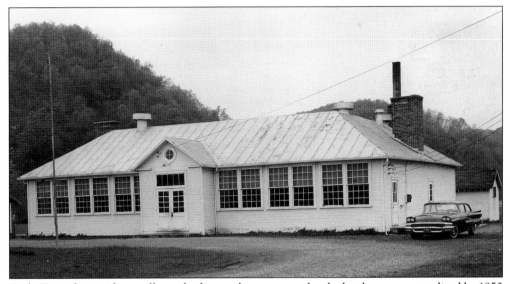

Eagle Township, with no villages, had several one-room schools that became centralized by 1950 into this three-room building in Eagle Mills for grades one through eight. The school closed after the spring term in 1962; students then attended Allensville Schools. Jean Davidson recalls teachers Ruth George, Julia Watson, and Otis Holden and cook Zelma Jones and janitor Mae Routte. The building no longer stands. (VCHGS.)

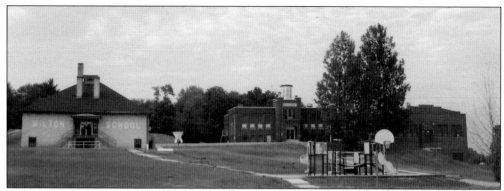

This May 2007 photograph shows the main Wilkesville School building and part of another. Until the mid-1920s, Wilkesville had the only four-year high school in Vinton County other than McArthur and Hamden. The high school closed in 1966, and the elementary school closed not long after this photograph was taken. (Courtesy of Betty Lou Wells.)

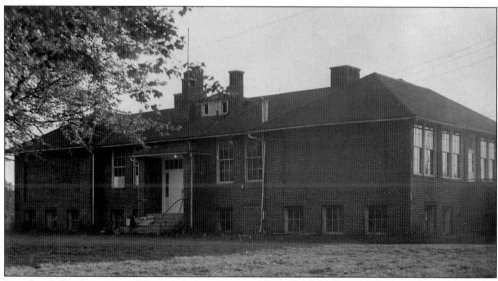

Dundas School was in a "special district" apart from Clinton Township. A 1925–1926 school report used Dundas Junior High, while a photograph is labeled "High School at Dundas," so it may also have been a two-year high school. In 1942, it was labeled a "two-teacher school." It closed sometime later, but in 1966 it reopened to house vocational agriculture classes at Vinton County High School. (Courtesy of Jean and Clarence Ward.)

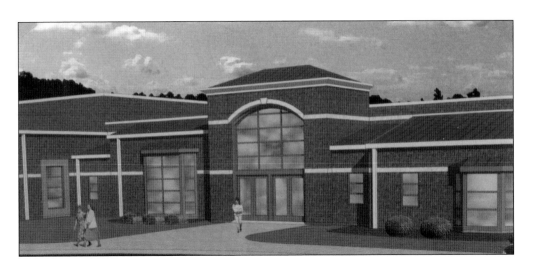

Following the consolidation of the five school districts into the single Vinton County Local School District in 1966, the elementary schools were still in use in their local communities. Junior high students were bused to the former high school building in Allensville, and high school students went to the former McArthur High School building. State school funding and local millage resulted in a new Vinton County High School building at the western edge of McArthur in 2000, a middle school at the same location (2007), and Central Elementary in McArthur (2007), South Elementary north of Hamden (2007), and West Elementary in Allensville (2008). The latter school is pictured above. The photograph below shows the lettering affixed to the gym entrance of the old McArthur High School building donated by the 1967 class for the newly consolidated Vinton County High School. (Above, courtesy of Joe Coleman; below, VCHGS.)

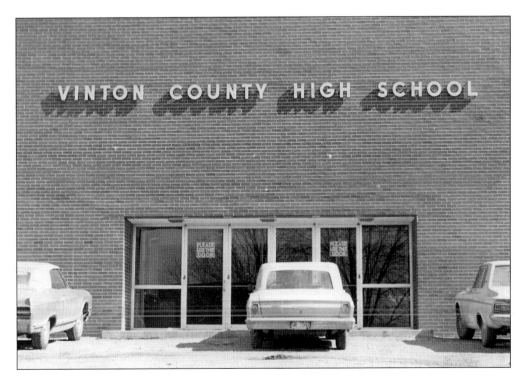

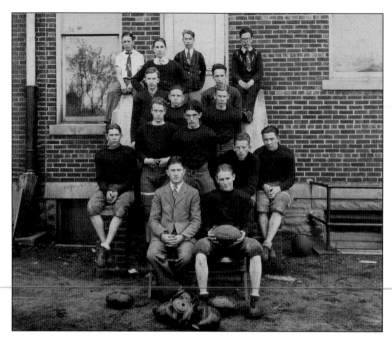

Smaller high schools, including Hamden, often fielded football teams in the years between World War I and II. Many schools had what was termed six-man football, which eliminated guards and tackles from the offensive line and one person from the backfield. This may have been the case with this team, posing in 1929. (Courtesy of Alberta DePue collection.)

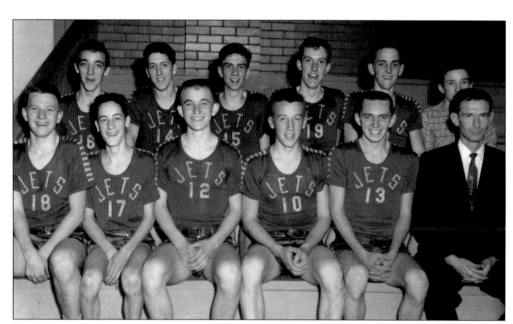

Until 1966, when all five of the county's high schools were merged into Vinton County High School, the Wilton Jets competed with schools in neighboring counties and the other four high schools in Vinton County: Allensville Bombers, Hamden Engineers, McArthur Generals, and the Zaleski Bob Cats. This is a team photograph from the early to mid-1960s. Vinton County is the Vikings. (Courtesy of *Courier* files.)

Five

NATURE, FORESTS, AND RECREATION

As residents of Ohio's most lightly populated county, Vintonians have perhaps a closeness to nature not felt by Buckeye urbanites. According to the most recent estimates, 82.46 percent of the land is forest, compared to 6.5 percent of cropland and 9.3 percent of pasture. While much of the woodland is not in commercial timber, having been cut over several times, timber harvesting is still economically significant. Some forestland is publicly owned and in the Wayne National, Zaleski State, Vinton Furnace, and Tar Hollow Forests, but 86 percent is privately owned (including by corporations). There were 406 persons who worked in the timber industry in 1947 compared to 189 in the latest report, but the total value of forest products is much greater, exceeding $30 million.

Forestland has always attracted sportsmen for hunting, fishing, and trapping. Deer and wild turkey are especially plentiful. Hides of small fur-bearing animals such as raccoons, muskrats, and mink provided extra income for farmers and trappers in earlier days, although they are less prevalent in contemporary times. It is possible for nature lovers to catch a glimpse of wildcats and black bears in the deeper woodlands. Coyotes have become more common.

Three state-owned lakes offer boating, fishing, camping, swimming, and hiking. Lake Alma has a history dating back more than a century. Lake Hope was built during the Great Depression, and Lake Rupert Wildlife Area is a product of the late 1960s and much less developed than the two older state parks. As for Tar Hollow, much of it lies in Ross and Hocking Counties except for some forestland in Vinton. In addition to the state parks, some private development has taken place, for example, Ravenwood Castle, small craft businesses, and cabins neighboring the Hocking Hills. Efforts are being made to foster tourism. Nonetheless, enough opportunities already abound to justify Vinton County's best-known slogan, "Nature at Its Best."

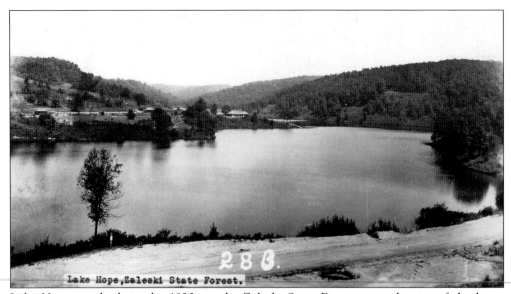

Lake Hope was built in the 1930s in the Zaleski State Forest, near the site of the long-abandoned charcoal and iron Hope Furnace. Lake Hope State Park, shown here about 1950, continues to be a popular recreation spot, attracting about a quarter-million visitors each year. (Author's collection.)

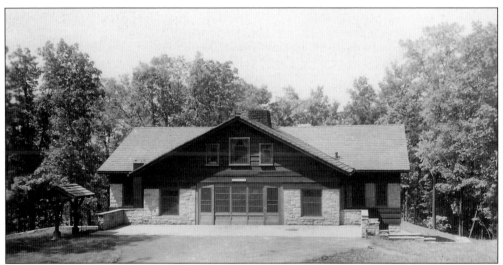

The Lake Hope Lodge was built in 1950 of local timbers and regional stones. It featured a dining room, terrace overlooking the lake, and meeting areas. The lodge was a favorite place for locals and visitors. It burned to the ground in February 2006. A rustic lodge built on the same site opened in the fall of 2012. (VCHGS.)

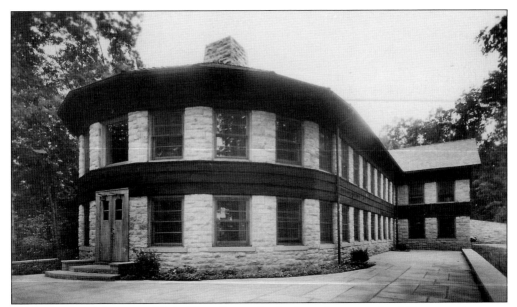

The rear view of the original Lake Hope Dining Lodge from the terrace level illustrates the many regional stones used in its construction. The terrace point overlooked Lake Hope and served as the background for many photographers. It was not unusual to find a small music group on the terrace entertaining visitors to the lodge. (VCHGS.)

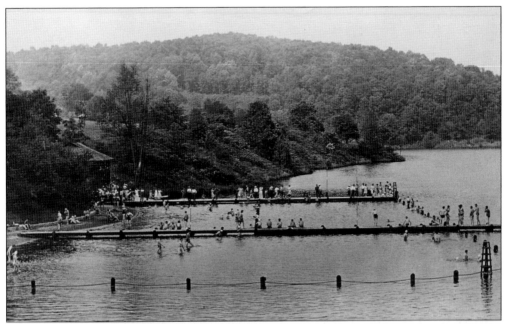

The swimming beach at Lake Hope State Park, seen here in the 1970s, was the place for the area's young people to gather in the summer. It is still an attraction for those staying at the park. The Nature Center, in another section of the park, employs a naturalist. It has provided fun and education for visitors of all ages. (Courtesy of Betty Lou Wells.)

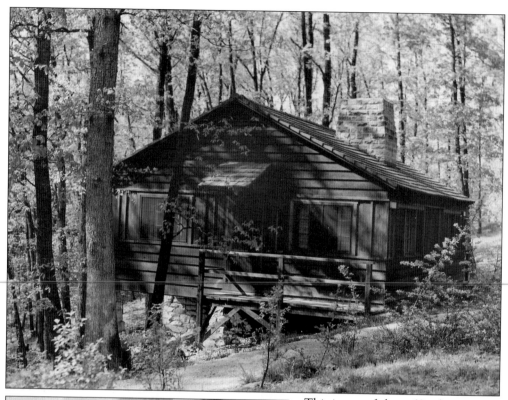

This is one of about 60 cabins or cottages available for lodging year-round at Lake Hope State Park. Most of the cottages are designated with the name of the wood used in its construction. A campground, rent-a-camp, and a horse camp are also well patronized. The park and lake are named for the 1880s mining community of Hope. (VCHGS.)

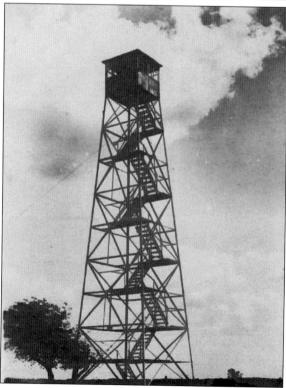

The Atkinson Ridge Fire Tower, a Madison Township landmark, was the last remaining such structure in Vinton County. Built during the Depression, it was first used in 1930. The tower was no longer needed by the mid-1970s, when more modern ways of fire detection became available. It was a favorite visiting place by the public for viewing the hills and countryside. (Courtesy of Betty Lou Wells.)

Lake Alma State Park comprises about 300 acres and has a 60-acre lake surrounding an island with a walking path. Located in Clinton Township (and a bit in Jackson County), the park lies east of State Route 349. There are plenty of opportunities for camping, fishing, hiking, seasonal swimming at the two small beaches, riding the bike path, and enjoying the scenic beauty year-round. (Author's collection.)

In 1926, Wellston City bought Lake Alma as a water reservoir. It and the surrounding area became a state park in 1950. Remnants of the amusement facilities are long abandoned. The footbridge seen here was replaced in 2013 with a new one, allowing hikers to again traverse Davis Island. (VCHGS.)

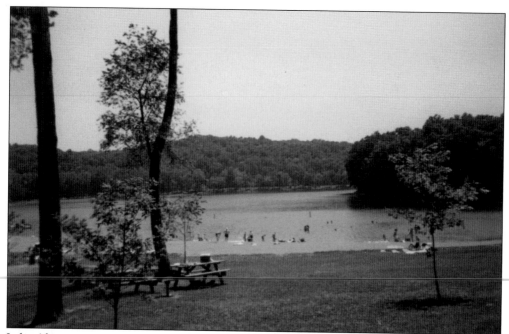

Lake Alma was conceived by Wellston businessman Charles K. Davis as the central feature of an amusement complex named for his wife. It opened in 1903 and lasted about seven years as a private recreation area. Davis Island featured a dance pavilion, outdoor theater, and merry-go-round. Streetcars transported patrons from Jackson County. (VCHGS.)

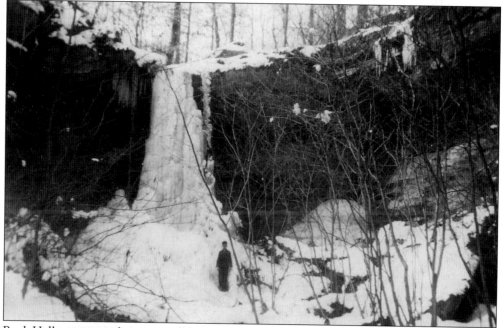

Rock Hollow, a natural site not well known in Vinton County, is located in Elk Township in the rugged area between Frazee Lane and Wolf Hill Road. The height of the frozen waterfall can be appreciated by looking at the person seen standing at its base. Nearby folks once used the area behind the waterfall for refrigerated storage in winter. (Courtesy of Rose Ann Jarvis Bobo.)

90

Lake Rupert, along State Route 683 one-half mile north of the intersection with State Route 93, is a 1,414-acre area within the Wellston Wildlife Area (above). Located in Clinton and Richland Townships, the lake was built in 1969 in a cooperative effort between the Ohio Department of Natural Resources and Wellston as a water supply for the city and as a recreation site for hunting, fishing, and boating. The lake itself (below) comprises about 330 acres, with a nine-mile shoreline. During construction of the lake, the water covered Tinker Road and the Bay covered bridge was relocated to the Vinton County Junior Fairgrounds. (Both, author's collection.)

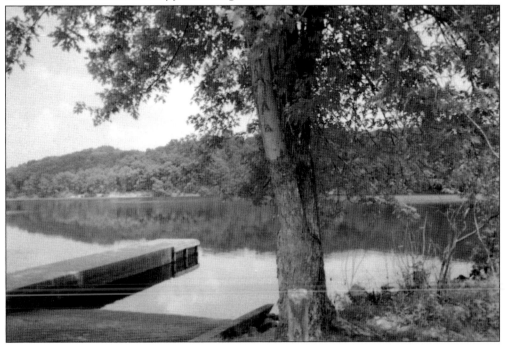

The wild turkey had become almost extinct by the early 1900s. In the late 1950s, Ohio began relocating the fowl, with the first ones from other states being stocked in Raccoon State Forest in Vinton County, a favorable habitat for the birds' proliferation. Spring and fall hunting seasons attract hunters from many locales. Here, Steve Largent poses with a harvested wild turkey in 1982. (Courtesy of John and Connie Staneart Largent.)

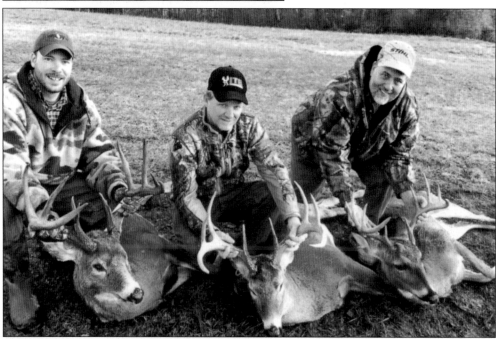

In the 1950s, seeing a white-tailed deer was a special sight. By 2015, it is common, and encounters between deer and vehicles happen frequently. Wooded, dense areas and cornfields have encouraged the dramatic increase in the deer population. Many hunters travel to the county during deer-hunting season. These hunters show off antlered deer taken in Brown Township. (Courtesy of John and Connie Staneart Largent.)

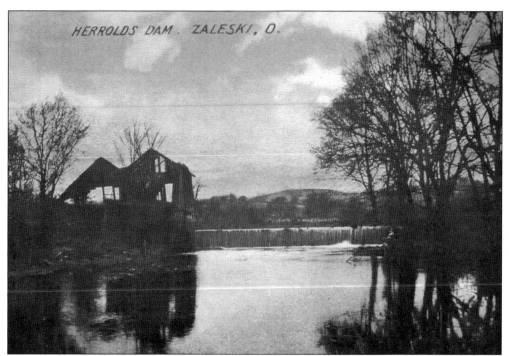

Little is known about Herrold's Dam, located near Zaleski, but it shows up in several postcard photographs. The large dam was located on Little Raccoon Creek, with one of the largest water mills in the area. It is believed that a covered bridge was nearby. (Courtesy of John Cline.)

The water reservoir pictured here in 1912 was located southwest of McArthur. The biggest reservoir covered about 12 acres. Started in the 1860s, it powered a water gristmill and became a popular recreation place for reunions, fishing, boating, swimming, and ice-skating. The big reservoir had a break in the 1890s, but the other two reservoirs were left intact. (VCHGS.)

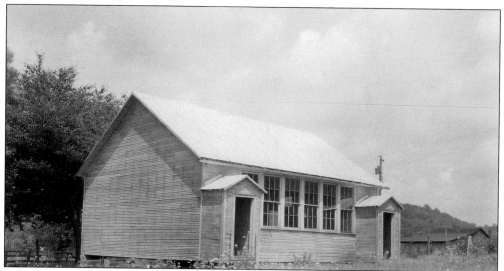

There were two Hope one-room schools, both located in the same place. The first, built in 1883, was on a half-acre plot obtained from Aaron Pinney. It flourished until 1931, when it burned down. The new Hope School thrived for a decade and closed in 1941. In the late 1990s, a restoration project refurbished the old school, which reopened as a historical interpretative site. (VCHGS.)

Clyde Pinney (left) and the late Johnny Williams were long associated with Hope School, going back to when they were students there. Both were active in the project to refurbish the building. For years, while health permitted, they spent several hours each weekend as hosts and guides for visitors to Hope School, which is located on Wheelabout Road/Pinney Hollow near Lake Hope State Park. (Author's collection.)

Six

NOTABLE PEOPLE, PLACES, AND EVENTS

Although small in comparison to most cities and counties, Vinton County has made contributions to the state and nation. In the 19th century, Thomas Wren of McArthur moved to Nevada and served a term in the US Congress. Local attorney Homer E. Abele also was a congressman for one term (1963–1965) and later served 24 years as an appellate court judge. In the World War I era, local attorney Otto Vollenweider spent two terms in the state senate. William McKinley (governor and later president) campaigned here, as did Pres. Richard Nixon in the 1960s. Nixon has ancestors buried at Mt. Pleasant. Perhaps the most dramatic event was Morgan's Raid by Confederate general John Hunt Morgan in July 1863. Periodic reenactments take place in Wilkesville.

Vinton Countians were at a high level of community spirit when the 1950 centennial took place. Several photographs in this book capture the excitement. Other longtime events include the Wilkesville Bean Dinner every September since 1869 and the fish fry on the public square in late July. McArthur has a 4th of July celebration, and the county fair is always a busy place, with youth exhibiting their projects. The Wild Turkey Festival has been an annual event since 1985. Churches and communities have had reunions for many years, including Richland Township Reunion at Shiloh Park and the St. Sylvester Homecoming in Zaleski.

While Vinton County has no national parks, there are landmarks worthy of note. These include the octagonal barn in Swan Township, the artwork of the "fox and hounds" barn in Eagle Township, and the easily viewed Bicentennial Barn on State Route 93. Those interested in 19th-century industrial history can examine the stacks of Hope Furnace near Lake Hope State Park. Remnants of Vinton and Richland Furnaces take somewhat more effort to visit, as do the railroad tunnels, but those who do will find them worthwhile.

Life in Vinton County has not always been easy. Nonetheless, many of those who make their homes here possess the same sense of community pride found in small towns and rural America.

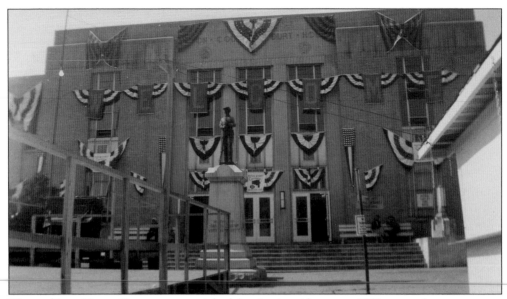

The weeklong Vinton County centennial celebration in mid-summer 1950 was a gala event, among the biggest in the county's history. Pictured here is the well-decorated courthouse. Both Gov. Frank Lausche and his Republican opponent, state treasurer Don Ebright, were in attendance. Ebright was a judge for the famous beard contest. (Courtesy of Clara Jane Dodrill.)

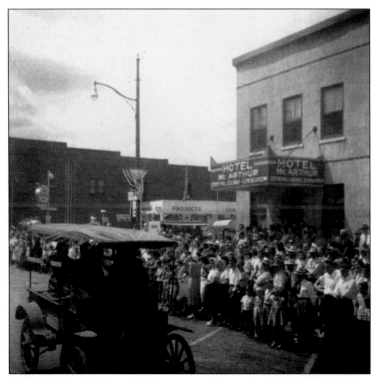

Among the unique antique vehicles that participated in the Vinton County centennial parade of 1950 was the early REO pickup truck, driven by Milford Harden. The car looked more like a "horseless wagon" than a "horseless carriage." The vehicle, still in existence, is owned by Vicky and Mike Schlosser of Albany. (Courtesy of Vicky Schlosser and Steve Warthman.)

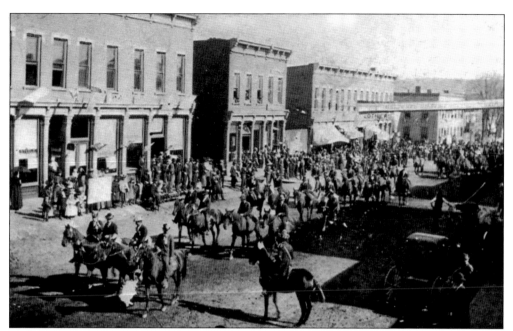

William McKinley visited Vinton County in McArthur while campaigning for governor of Ohio. A large parade with many residents on horseback added to the festivities, as seen here. McKinley was elected governor in 1891 and 1893. He was elected president in 1896 and was assassinated in fall 1901, early in his second term. (VCHGS.)

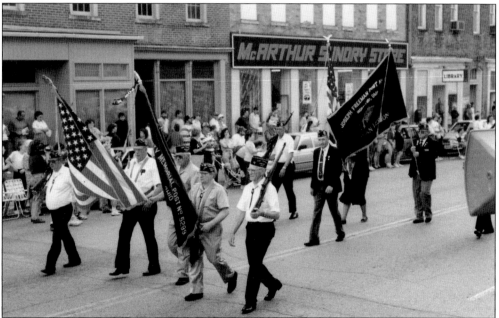

Patriotism is an important value of Appalachian people, including for those in Vinton County. Parades begin with an honor color guard comprised of local veterans. Memorial Day, July Fourth, Wild Turkey Festival, and Christmas are some of the occasions for parades in Hamden, McArthur, Wilkesville, and Zaleski. Note the location of the library in this May 1992 photograph. The site now houses McArthur's Village Hall. (Author's collection.)

Parades are occasions for the county's youth programs to participate in community events. Seen here is a group of Girl Scouts and Brownies at the beginning of a parade route in McArthur in the mid-1980s. Other active youth groups include those affiliated with churches, Boy Scouts, 4-H, Little League, and school-related FFA (Future Farmers of America) and FHA (Future Homemakers of America). (Courtesy of the Vinton County Extension Office.)

The Wild Turkey Festival has been an annual event in McArthur, the county seat, since its inception in 1985. It is the main event of the Vinton County Travel and Tourism Committee, an organization emanating from OSU Extension's community development program. The festival began as a local down-home celebration featuring the wild turkey. It is now a much larger street fair. (Author's collection.)

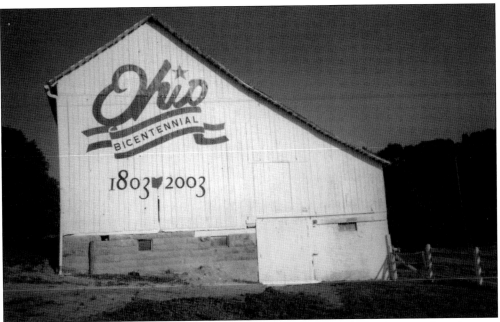

Among Ohio's celebration of its bicentennial in 2003 was the painting of its logo on a barn in every county. The Vinton County Ohio bicentennial barn is located on Gene and Garnet Engle's property on State Route 93, north of Creola. More than 100 people joined in the dedication festivities. The barn dates to about 1900, when it was built by Carney and Alta Johnson. (Author's collection.)

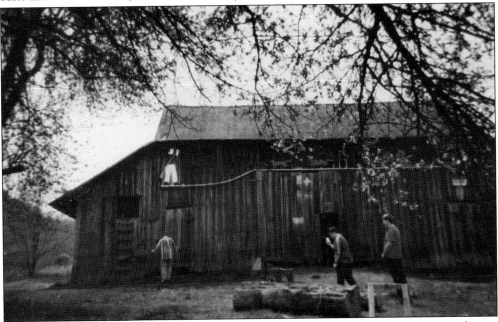

An unusual folk-art decoration adorns this barn on Pretty Run in Eagle Township. According to Nina Fox, the barn and its decorative art dates from the early 1860s, when her grandfather Thomas Slagle built it and did the artwork, with some help from his wife, Amy. Although the artwork has faded with time, it is a reminder of activities like fox hunting, which was more common in years past. (Author's collection.)

The Wilkesville Bean Dinner has been a September tradition since 1869. It was held in four or five locations, including the village, before permanently settling since 1946 in the American Legion Grove just beyond the county line. The late Meryl Houdasheldt, longtime bean cooker, is shown preparing to serve beans that have been cooked for several hours in kettles over open wood fires. (Author's collection.)

Live entertainment has especially been a feature of the Wilkesville Bean Dinner. Seen here in the 1980s, Donna Stoneman of the well-known Stoneman family plays mandolin and sings for the listeners. Stoneman, from Nashville, also does evangelistic work and has preached in revivals in both McArthur and Hamden as well as at Beaver in Pike County. (Author's collection.)

ROAR Day (Rural Ohio Appalachia Revisited) began in the mid-1980s and has been held annually in October at Lake Hope State Park. Emmett Conway (left), "the olde forester," was active in forestry, conservation, and preservation programs. He oversaw construction of Ohio's first state park lodge at Lake Hope. Conway was inducted into the Ohio Department of Natural Resources Hall of Fame in 2013. Rod Garey (right) was manager of the park at the time of this photograph. (Author's collection.)

The Vinton County Junior Fair has been a showcase for 4-H, FFA, FHA, Girl Scouts, and Boy Scouts to exhibit their project work. Local and regional businesses and organizations support youth and the fair in many ways, including the livestock sale. Pictured here in the 1980s are Bob Will Jr. (left) of the Vinton County National Bank and a 4-H member with the lamb just purchased. (Courtesy of the Vinton County Extension Office.)

In October 1960, Vice Pres. Richard Nixon made a campaign whistle-stop in Hamden at the depot. It was a major political event in Vinton County considering that Nixon's father and grandfather had been born there. His grandfather is buried in the cemetery in Mt. Pleasant. Whether running for vice president or president, candidate Nixon ran well, carrying Vinton County handily five times. (Courtesy of Alberta DePue collection.)

Samuel Nixon, a native of Washington County, Pennsylvania, died in 1914 at age 66, survived by his second wife, Luthera. The Nixons had been Democrats, but Pres. Richard Nixon's father, Frank, son of Samuel, became a Republican in the McKinley era. Samuel, his first and second wives, and oldest daughter Irene are buried in the Mt. Pleasant Cemetery in Swan Township. (VCHGS.)

Homer E. "Pete" Abele (1916–2000) was the only resident Vinton Countian elected to the US Congress, serving a single term (1963–1965). A former highway patrolman and a practicing attorney in McArthur, Abele had earlier served Vinton County in the state legislature (1949–1952). Beginning in 1967, he spent 24 years as a judge on the Fourth District Court of Appeals. (Author's collection.)

Inducted into the Ohio Women's Hall of Fame in 2000, Maude Collins was a pioneering woman in law enforcement. She was Ohio's first female sheriff, appointed to complete her murdered husband's term. She was then elected by a landslide to her own term. Sheriff Collins solved a double homicide, bringing her national attention. She is buried in Hamden Cemetery. (VCHGS.)

Dr. Charles Boardman Taylor (1846–1928) was a well-known Presbyterian minister and local historian. He served churches in Wilkesville, McArthur, and New Plymouth at various times. He wrote the booklet "History of Wilkesville and Salem Township" (1874), edited the short-lived pro-Grant newspaper *Wilkesville Reporter* in 1872, and wrote the Vinton County section in *History of the Hanging Rock Iron Region* (1916). (VCHGS.)

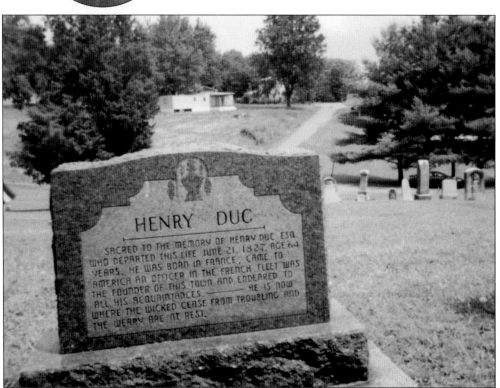

Henry Duc (c. 1763–1827), of French birth, has been honored with this marker in the local cemetery as the founder of Wilkesville. He laid out the townsite in 1810. The township, named for the original landowner, Mr. Wilkes, dates from 1815. A land agent for Wilkes, Duc was highly revered by the early settlers. (Author's collection.)

Herbert Wescoat Memorial Library moved into its new facility in June 1992. The first public library in McArthur opened in 1934 in the Memorial Building, becoming the Vinton County Public Library the next year. In 1962, the library moved to West Main Street, remaining there for 30 years. Vinton County native Charles B. Wescoat willed his estate to the library in remembrance of his deceased wife and son. (Courtesy of Gayle Young.)

Pictured are members of a McArthur Christian Church class at the Gibson Hotel in Cincinnati on January 28, 1949. They attended the Ruth Lyons Show. Her radio-variety program over WLW was very popular. Several Vinton County groups made special excursions to see and be a part of the live audience. (VCHGS.)

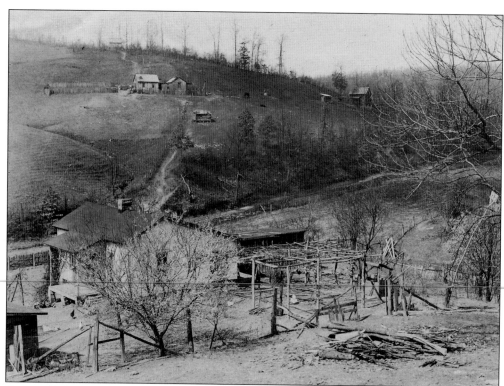

For a small county, Vinton has had several sensational murders. This photograph shows the Stout farm in Vinton Township, where Sarah Stout was killed in November 1926. Her husband, Bill, was murdered in February 1927. Sheriff Maude Collins solved the case, which captured national attention. The family's son Arthur Stout and his girlfriend, Inez Palmer, received life sentences for the murders. Accounts of the murders read like detective thrillers. (VCHGS.)

$1000 REWARD

The Vinton County Commissioners and the Buckeye Sheriff's Association are offering a $1000.00 REWARD for information resulting in the Apprehension of one OLIVER MILLS. Mills is wanted on a warrant on file for the Murder of Harold Steele, Sheriff of Vinton County. ALL INFORMATION will be handled in a confidential manner.

Please call McArthur 596-4502 collect.

Harold Steele (1909–1970), a Swan Township native, was elected sheriff of Vinton County in 1960 after having served as a deputy. Steele was killed in the line of duty in late summer 1970 by Oliver Mills, who was subsequently apprehended, tried, and convicted. This reward poster appeared while the suspect was still at large. (VCHGS.)

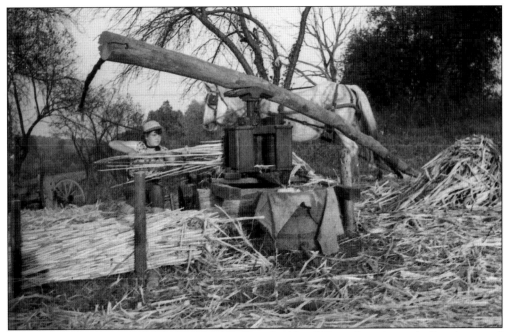

The Lemaster family lived near Shiloh Church in Richland Township. An early-October ritual was making sorghum molasses, to be enjoyed throughout the winter. This 1950s photograph shows someone milling the cane to squeeze out the juice, which would need stirring and cooking for several hours. A daylong process, it was often an enjoyable tradition for families. (Courtesy of Rose Ann Jarvis Bobo.)

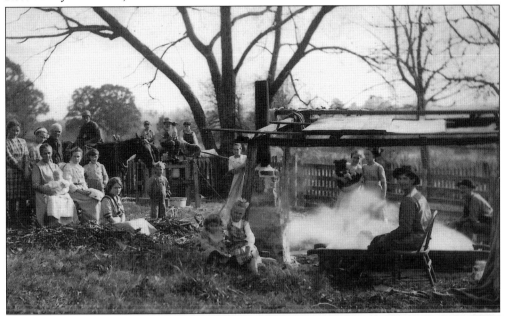

The O.H. Kinsel family cooks down sorghum at the farm of their neighbors, the H.H. Tripp family, in the fall of 1912. The large farm was located near Hamden in Clinton Township, close to the Jackson County line. H.H. Tripp was very active in the Winters M.E. Church. The Tripp family cemetery is nearby. (Courtesy of Alberta DePue collection.)

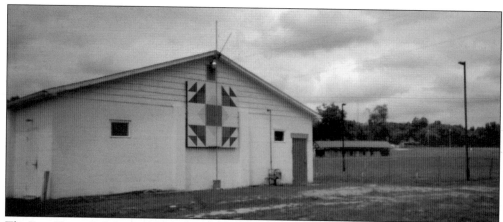

The Fern Kruger Exhibit Building was the first such structure built on the junior fairgrounds north of McArthur in the late 1960s. One of the county's 27 quilt barns, the summer winds pattern is on this building. Fern Kruger served many years as secretary in the Vinton County Extension Office and was active with the fair board. (Author's collection.)

4-H is the youth development program of the Cooperative Extension Service, as it was known at the time of this late-1960s photograph. Extension, outreach education of the land grant Ohio State University, began in Vinton County in March 1922; eight years earlier, the extension service came about with the Smith-Lever Act. Sherry Harper Graves (pictured) served as a summer assistant, working with the 4-H program and fair activities. (Courtesy of *Courier* files.)

Vinton County's 4-H program has provided local youth and adult advisors with educational projects for "learning while doing." Shown here presenting Vinton County's contribution to Mr. Cashman (seated) of Ohio Farm Bureau in 1970 are, from left to right, advisor Tom Park, OSU dean Roy Kottman, agent Bob Davis, council member Fred Weaver, and 4-H member Sarah Hulbert. The donation went to the state's 4-H center. (Courtesy of the Vinton County Extension Office.)

The Vinton County Soil and Water Conservation District (SWCD) was established in 1946, with Howard Wells of the Wilkesville area one of the "founding fathers." This 1990s photograph shows the large attendance that this organization draws for its annual banquet. Dedicated to resource development, SWCD has promoted and provided technical assistance for wise use of the county's natural resources. (Courtesy of the Vinton County Extension Office.)

Affectionately called the Raccoon Valley Sweethearts, sisters Frances Tripp (left) and Clara O'Leary, both of Zaleski, are pictured here in the early 1980s entertaining at an OSU Extension Spring Achievement event. Besides homemaker club activities, Frances and Clara sang at local community activities, family reunions, and for their own enjoyment. (Author's collection.)

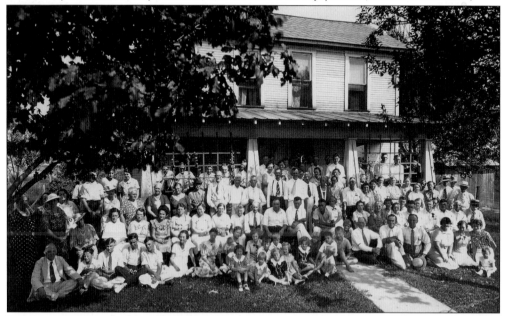

Family reunions took place throughout Vinton County and much of rural America in earlier times, and some continue today. Shown here is a reunion primarily of the Allen, Clark, Harden, Newman, and Warthman families in September 1936. This reunion on Locust Grove Ridge took place annually over many years. It was held as remembered by a Harden nephew, Arthur Warthman, at least from 1921 to 1938 and likely for several years thereafter. (Courtesy of Vicky Warthman Schlosser.)

Seven

RAILS, ROADS, TUNNELS, AND BRIDGES

For those in the 21st century accustomed to rapidly moving automobiles and airplane travel, it is difficult to comprehend travel challenges of 200 years ago. The 1814 account of Charlotte Bothwell provides some insight. Departing from Pittsburgh on a Wednesday in a flatboat, her party reached Marietta on Saturday. From there to Gallipolis was slower, taking five days. By wagon from Gallipolis to Jackson was a two-day trip, and then it was another two days to the site of McArthur. The passing of time led to transportation improvements, but they came slowly.

Rail travel seemed rapid by comparison, but it was still slow by today's standards. The rugged terrain made tunnels a necessity; there were four on the Baltimore & Ohio Railroad and two on the Hocking Valley Railway just in Vinton County. More significant than its use in passenger traffic, railroads transported Vinton County's natural resources. Passenger service on the Chesapeake & Ohio Railway terminated at the end of 1949 but continued on the B&O through most of the 1960s and briefly on Amtrak in the late 1970s, although it did not stop in Vinton County.

Horse-and-wagon travel improved somewhat, mostly through the construction of bridges over streams and some road improvements. Real highway improvements came with the automobile and the demand for smooth roadways linking the major towns. This became a reality in the 1920s, but many county roads were not paved until a generation later. Automobiles were initially thought of as "rich man's toys," but by the 1920s the price of a Model T Ford had dropped to $295, and average folks could finally afford them.

Airplanes made less impact locally, but primitive airfields existed in McArthur (doubling as a ball field) and near Zaleski (used by the forest service). Finally, in the 1960s, the Vinton County Airport was constructed, with state subsidy, in Swan Township on reclaimed strip-mine land. Meanwhile, highway quality has continued to improve, but to date the only four-lane highway is that portion of the Appalachian Highway that passes through Vinton Township.

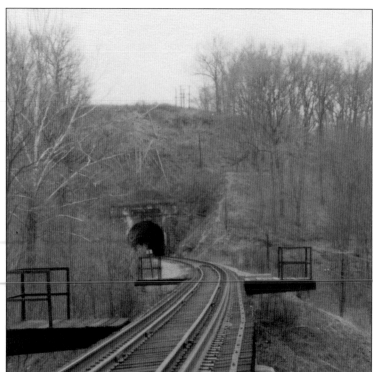

Moonville Tunnel was completed in 1903 on the Baltimore & Ohio Railroad's main line. Although the rails and trestle were torn out in the 1980s, the tunnel remains a favorite destination for hikers. Local lore claims it is haunted by the "Moonville Ghost." A rail trail is being developed along the abandoned track. (Author's collection.)

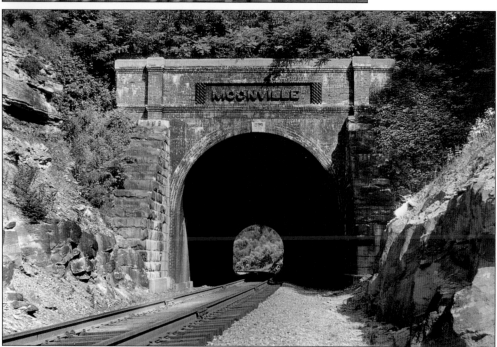

This photograph provides a close-up view of Moonville Tunnel from its western entrance at a time when six passenger trains passed through it daily, including the National Limited. To get this close, pedestrians had to cross a lengthy, high, narrow trestle spanning Raccoon Creek. (Courtesy of Moonville Rail-Trail Association.)

The Campbell Tunnel between Radcliff and Hawk Station on the River Division of the Hocking Valley (later C&O) Railroad was in use from 1880 through 1979, when the last train ran through it. Carved through solid rock and 896 feet long, the tunnel was barely wide enough for rail cars. Both entrances can still be seen. (Courtesy of Ivan Tribe.)

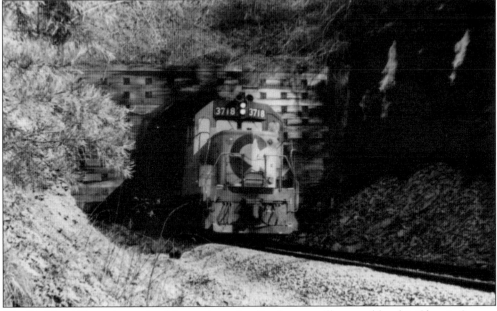

The Richland Tunnel remained in use into the diesel era, as illustrated by this Chessie System locomotive with the sleeping kitten silhouette in plain sight. The 125-foot-long tunnel was about 100 yards from Richland Furnace (also known as Cincinnati Furnace), which once supported a thriving community around the charcoal-iron furnace. The furnace closed many years before the post office did in 1915. (Courtesy of Lawrence McWhorter.)

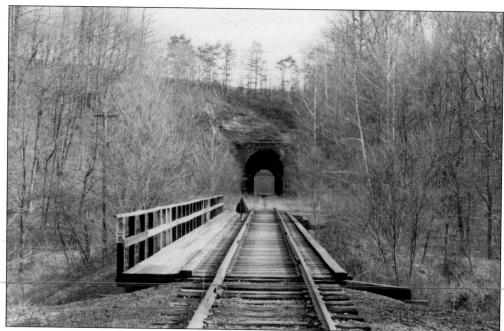

The Eagle, or Oreton, Tunnel was on the River Division about three-tenths of a mile south of Oreton. The tunnel is 340 feet long. The last train went through the tunnel in June 1979. The south entrance, boarded up since the rails were removed, is visible from the bridge on Route 160 in winter or after the leaves have fallen. The tunnel's north entrance, facing south, is pictured here. (VCHGS.)

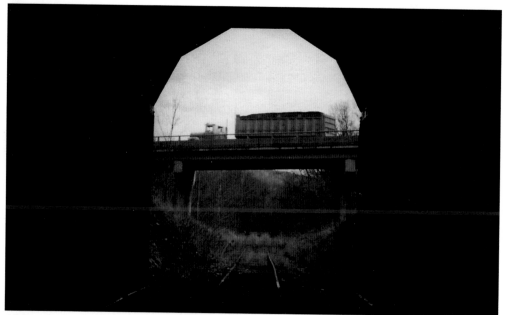

Although the C&O Railway had abandoned its River Division line, the tracks had not yet been removed, and the Eagle Tunnel remained open when this early-1985 photograph was taken from just inside the south entrance. A coal truck crosses the bridge on SR 160, heading south. (Courtesy of Lawrence McWhorter.)

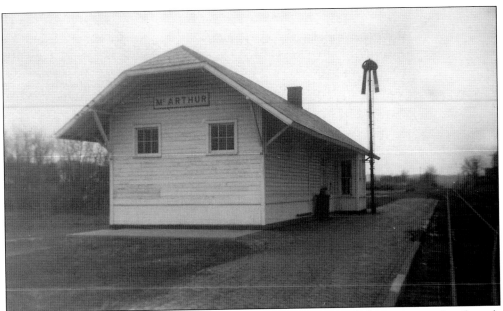

The McArthur Depot, at the lowest part of East High Street, served the county seat's rail needs from 1880 until 1964, when it closed. It was torn down the next year. Passenger service ended on December 31, 1949, but the McArthur Depot continued as a freight station for another 15 years. (Courtesy of Ivan Tribe.)

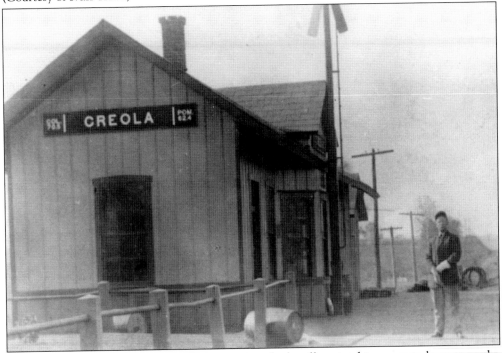

Creola was founded in 1880 as a shipping point for locally mined iron ore to be sent to the coal-fired iron furnaces in eastern Hocking and southern Perry Counties. The hamlet and the train depot (pictured here) outlasted the iron furnaces by decades. The depot closed in March 1940. (VCHGS.)

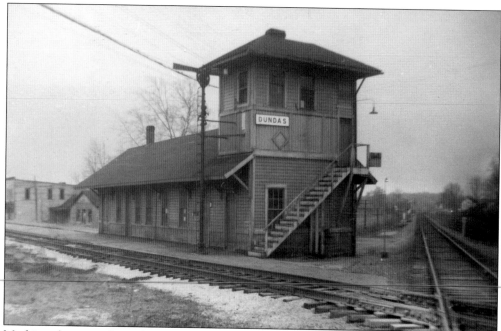

Marking the spot where the B&O and Hocking Valley (later the Chesapeake & Ohio) rail lines crossed, the Dundas Depot was a seven-day-a-week, 24-hour station until 1962. It is no longer standing. The photograph dates from April 1961, not many years before the station was demolished. The town of Dundas was originally called McArthur Junction. (Courtesy of Ivan Tribe and Jean and Clarence Ward.)

This close-up photograph shows the Zaleski Depot in 1960, when it remained an active freight station. The passenger car on the siding was undoubtedly from a work train. Maintenance workers may have stayed in the car while repairing the tracks. The last passenger train going through Zaleski was likely Amtrack in the late 1970s or early 1980s. (VCHGS.)

Although many still remember the B&O rail depot and passenger station in Hamden from which Vice Pres. Richard Nixon spoke during a whistle-stop appearance, almost no one recalls the Hocking Valley depot pictured here. According to Edward Miller's authoritative *The Hocking Valley Railway*, this station was built about 1897, closed in 1928, and was retired on January 23, 1930. (VCHGS.)

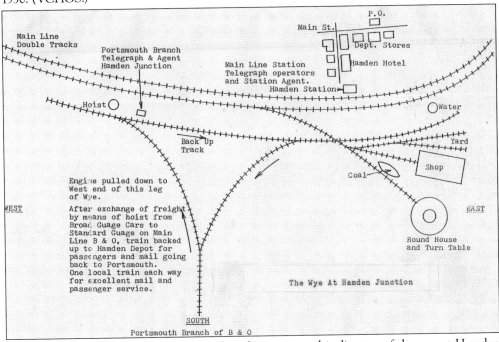

At one time, Hamden had a complex rail yard, as seen in this diagram of the wye at Hamden Junction. It was located where the Portsmouth branch of the B&O joined the main line that ran from Baltimore to St. Louis. This diagram does not show the Hocking Valley (formerly the Wellston & Jackson Belt), which also had a presence in Hamden. (Courtesy of Alberta DePue collection.)

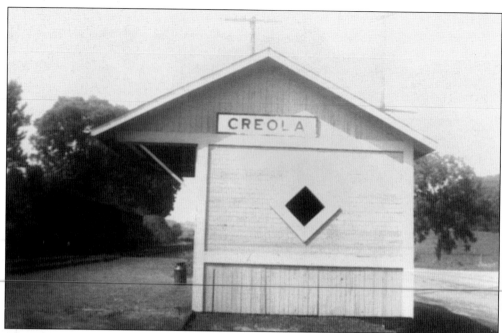

After the Creola depot closed in 1940, the Chesapeake & Ohio Railway replaced it with a smaller structure, known as a shelter shed, that stood for several more years. Today, only a few residences remain occupied from where in 1883 "large quantities [of iron ore] are shipped from Creola." (VCHGS.)

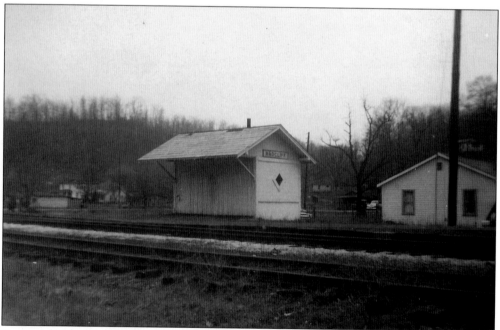

Between 1889 and 1939, there had been a small Hocking Valley Railway depot in Radcliff (also pictured in Hixon and Queen's *Vinton County Ohio History & Families*). After it was retired (railroad term for torn down), the Chesapeake & Ohio railway replaced it with this shelter shed, which remained through the 1950s. (Courtesy of Ivan Tribe.)

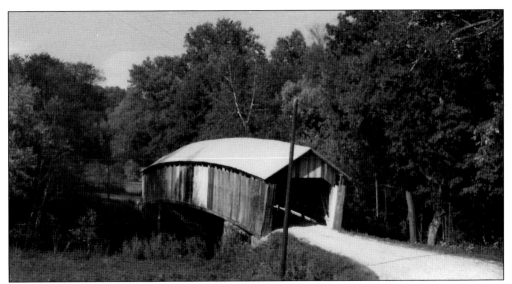

The 175-foot-long Ponn or Gheer's Mill covered bridge in Wilkesville Township spanned Raccoon Creek. Built in 1874, it was considered one of the most scenic and unusual of its kind. Although relatively isolated, it attracted tourists until being burned down by vandals in 2013, not long after being refurbished. Because of the nature of its span, it earned the nickname "the humpback bridge." (Author's collection.)

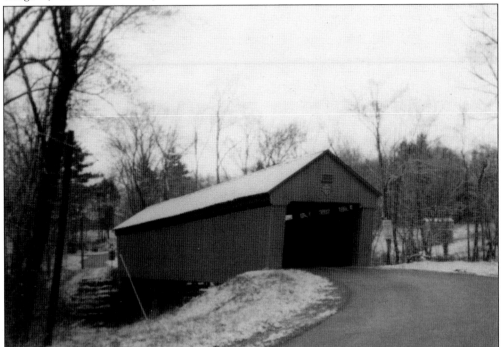

The Eakin's Mill covered bridge spanning Raccoon Creek near Arbaugh on Mound Hill Road is the only covered bridge in Vinton County open to automobile traffic. The bridge dates from 1871 and is a multiple kingpost design 114 feet in length. It has a slight hump or arch. The Vinton Township Garden Club was instrumental in saving the bridge and getting it refurbished. (Courtesy of Vinton County Extension Office and Betty Lou Wells.)

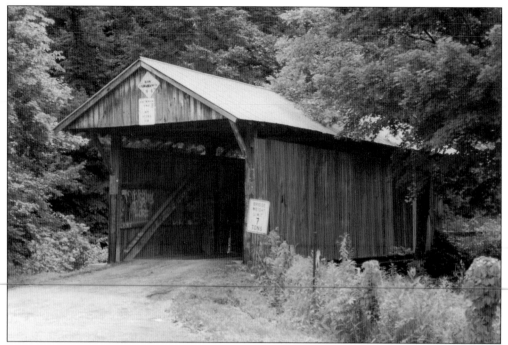

The Mt. Olive covered bridge, north of Allensville, dates from 1875. Only 48 feet long, it spans Middle Fork Salt Creek. Like many other shorter bridges, it is in the Queenpost style. It has been refurbished, but is only open for pedestrians, not automobile traffic. (VCHGS.)

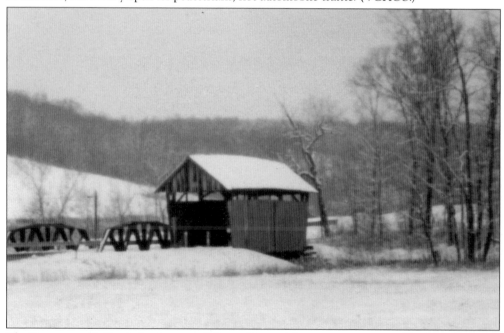

The Cox covered bridge is the shortest of Vinton County's four remaining covered bridges. Spanning Brush Fork in Swan Township, it dates from 1884 and is only 40 feet long. Easily visible from State Route 93, it is now closed to all but pedestrian traffic. Note the old iron bridge, itself becoming a historic structure, that was relocated to handle current traffic. (Author's collection.)

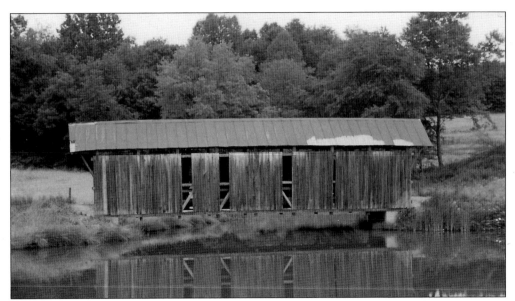

Moving the Bay or Tinker covered bridge from its original location on Tinker Road in Clinton Township to the Vinton County Junior Fairgrounds north of McArthur was a complex operation. Several local construction and trucking businesses physically moved the bridge. Ironically, this bridge was relocated about the same time that the Silver Bridge spanning the Ohio River from nearby Gallia County tragically collapsed. (Courtesy of the Vinton County Extension Office.)

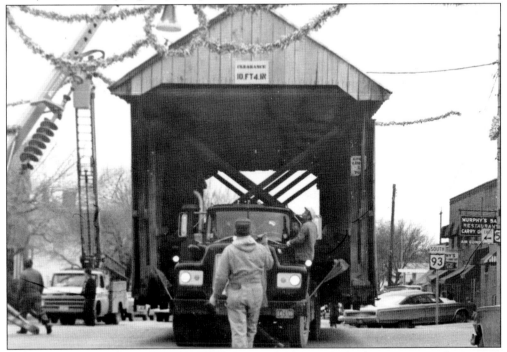

The 62-foot-long Tinker or Bay covered bridge was built in 1876 in the Kingpost style. In 1967, the structure was moved to the Vinton County Junior Fairgrounds, where it currently remains, used by pedestrian traffic only. The bridge is shown here at the traffic light in McArthur. The development of Lake Rupert necessitated the bridge's relocation. (VCHGS.)

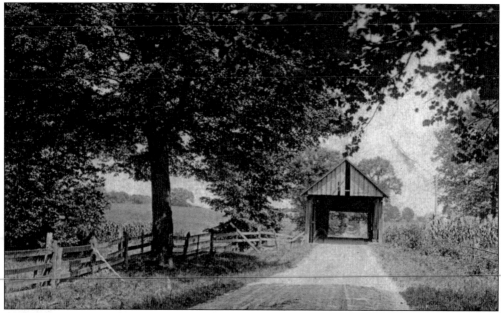

This short covered bridge, Robbins Bridge, spanned Little Raccoon Creek. It was located on State Route 160, about a quarter mile east of Hamden and north of Lake Alma. It was replaced many decades ago, and few have recollection of its existence. (Courtesy of Alberta DePue collection.)

Floods on Raccoon Creek are perhaps the most common in the area, but other parts of Vinton County are subject to flooding. This March 1997 photograph shows high water around the Knox Township house of Gilbert Smith, a neighbor of Keith and Madeline Staneart. (Courtesy of John and Connie Staneart Largent and Joyce Staneart Sheline.)

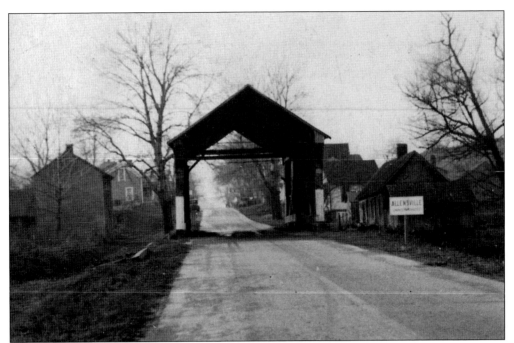

This short covered bridge stood at the east end of the community of Allensville, a part of which can be seen in the distance. Allensville, formerly known as Rileyville, acquired its current name in 1840. Its location in the western third of the county has made Allensville a site for one of Vinton County's elementary schools. (VCHGS.)

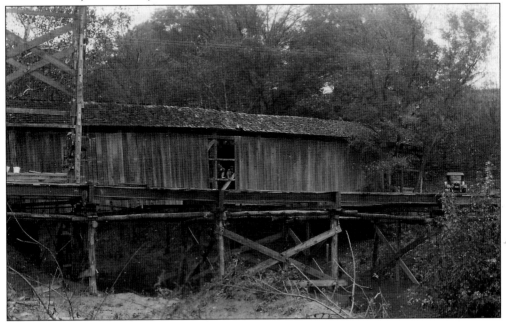

One of the most heavily used covered bridges in Vinton County crossed Raccoon Creek on State Route 160, just south of Radcliff on the way to Wilkesville. It also handled traffic going to and from Hamden and McArthur to Wilkesville. This photograph was taken in 1926. By 2014, no one was found who recalled the bridge's name. (VCHGS.)

The Ray or Timmons covered bridge spanned Middle Fork in the southern part of Harrison Township on State Route 327. Above, William Anderson and an unidentified child are seen with the bridge in the background and the creek nearly bank full, apparently following a heavy rain. The photograph below shows the same bridge after a truck with too high of a load went through and tore off the top of the bridge. It continued being used in this condition for some time until it was torn down in the late 1950s and never replaced. The highway was moved somewhat, with the new section circumventing where the bridge had stood. The "bones" of a covered bridge are very visible in this photograph. (Both, courtesy of Nyla Timmons Holdren.)

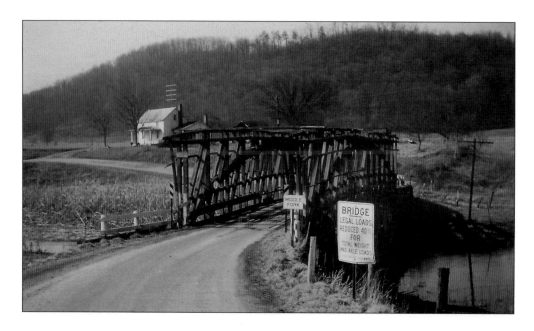

This photograph, taken on September 7, 1948, shows the crew of the Vinton County State Highway Department. As these were mostly political jobs at the time, it is likely that with the defeat of Gov. Thomas Herbert two months later many of these workers may have soon found themselves out of work. Currently, 13 state highways and one US highway traverse the county. (VCHGS.)

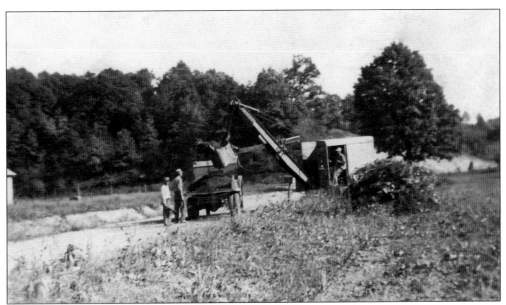

In October 1940, workers performed heavy labor with the equipment of the time, building State Route 683, a north-south route located entirely within Vinton County. Designated in 1937, the road follows the original routing of the highway. It begins about a half mile north of Hamden and ends at US Route 50, about six miles west of McArthur. (Courtesy of Rose Ann Jarvis Bobo.)

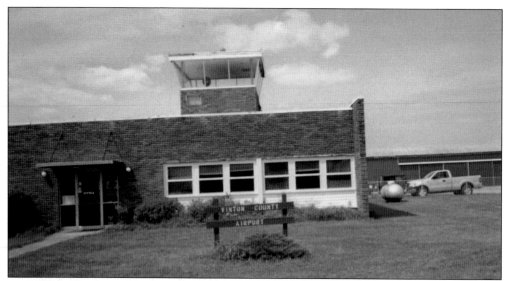

In 1967, Gov. Jim Rhodes declared that each county should have an airport. The following year, a runway was built on reclaimed strip-mine land donated by the Engle and Benedict Mining Company in Swan Township on Pumpkin Ridge. The grand opening occurred in 1970. Pictured is the administration building/terminal. The Vinton County Pilots and Boosters Association operates the airport and hosts the annual air show and other events. (Author's collection.)

In the 1940s, a passenger and mail train known as the "Doodlebug" ran from Portsmouth through Wellston, Hamden, Zaleski, and on to Athens and Parkersburg. It was diesel-powered and, in some respects, bore more resemblance to an oversized streetcar than a locomotive. These railcars were more common in the first part of the 20th century. (VCHGS.)

In the pre-automobile era, it was not uncommon for rural folks to travel in winter by horse-drawn sleds, as recalled in the still-familiar lyrics, "Dashing through the snow, in a one-horse open sleigh." Pictured here is a two-horse open sleigh! (VCHGS.)

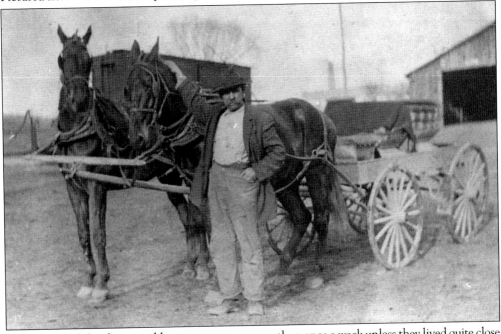

Before automobiles, farmers seldom went to town more than once a week unless they lived quite close to a village. Hitching and unhitching the horses was in itself time consuming. This unidentified farmer is either getting ready to go to town or perhaps just returning. Changing times make the final photograph in this book a nostalgic reminder of earlier times in Vinton County. (VCHGS.)

DISCOVER THOUSANDS OF LOCAL HISTORY BOOKS FEATURING MILLIONS OF VINTAGE IMAGES

Arcadia Publishing, the leading local history publisher in the United States, is committed to making history accessible and meaningful through publishing books that celebrate and preserve the heritage of America's people and places.

Find more books like this at
www.arcadiapublishing.com

Search for your hometown history, your old stomping grounds, and even your favorite sports team.